1982 Carnegie**International**

Introduction by Gene Baro

Museum of Art, Carnegie Institute, Pittsburgh

This catalogue is published in conjunction with the *Carnegie International* exhibition:

October 23, 1982—January 2, 1983
Museum of Art, Carnegie
Institute, Pittsburgh

February 10—March 27, 1983
Seattle Art Museum

June—November, 1983
Art Gallery of Western
Australia, Perth
National Gallery of Victoria,
Melbourne
Art Gallery of New South
Wales, Sydney

Sponsors

The 48th *Carnegie International* is made possible by a grant from Alcoa Foundation and income from The A. W. Mellon Educational and Charitable Trust Endowment Fund for the Pittsburgh International exhibition.

The Australian tour is supported by Alcoa of Australia Limited and arranged by the International Cultural Corporation of Australia Limited in conjunction with The Art Gallery of Western Australia, Perth.

In Australia the exhibition is indemnified by the Australian government through the Department of Home Affairs and Environment with assistance from the Australia Council.

Foreword

In 1896 Andrew Carnegie himself founded the exhibition now known throughout the art world as the *Carnegie International*. Of the five great, continuing exhibitions of contemporary international art (the *Biennials* in Venice and Sao Paulo, *Documenta* in Kassel, and the Guggenheim *International* in New York), the *Carnegie International* is second in venerability, its first edition coming a year after the initial Venice exhibition. Now in its forty-eighth edition, the *Carnegie International* has played a significant role in the cultural life of Pittsburgh and in the national and international art communities throughout its history.

While in the course of nine decades the exhibition has, from time to time, changed its format to accommodate contemporary artistic needs and demands and economic and political realities, it has nevertheless remained steadfast in its adherence to the founding ideals of Andrew Carnegie to provide for the education of the public, to serve as a vehicle for the enrichment of the Museum of Art's collections, and to "spread goodwill among nations through the international language of art."

Appreciating the value of the *Carnegie International* to Pittsburgh and recognizing that the exhibition historically has had the virtue of focusing the attention of the international art community on the city and its museum, in 1980 the trustees of The A. W. Mellon Educational and Charitable Trust established a major endowment fund at Carnegie Institute specifically for the exhibition's support. We are very grateful for this foresighted generosity which assures the perpetuation of a highly important undertaking on a scale commensurate with its distinguished tradition.

In recent years the exhibition has focused on the work of one or two artists in depth and, in fact, the kind of broad survey that the current edition represents has not been seen in Pittsburgh since 1970. It has become clear that, during the last dozen years, multiple styles emanating from a variety of international sources of creative energy have successfully proposed themselves as alternatives to the hegemony of modernist abstraction, particularly the sort associated with New York School traditions. Believing, in this artistic climate, that the large scale international invitational was once again an event of very considerable interest, the Museum of Art charged its Adjunct Curator of Contemporary Art, Gene Baro, with the responsibility for selecting an exhibition of no more than two hundred paintings and sculptures that would give each artist multiple representation. The works were to be made since 1979 and be of a scale that lent them to travelling *ensemble* since it was felt that the exhibition should tour to other museums. The only other specific guidance given to the curator was that, within the context of his standards of quality and interest, a range of styles be represented and that a balance be struck between emerging talents, established artists, and senior contemporary masters. Using these guidelines, Mr. Baro has selected an exhibition of 189 works by sixty-three artists from twenty-seven countries, chosen in the course of his travel to more than thirty countries around the world. Even for a person who, in his career to date, has made in excess of 200 exhibitions, many of them of major scale, this was an enormous task, and few individuals possess the energy and expertise to meet the kind of challenge he faced in the organization of this exhibition. We are fortunate indeed to have enjoyed his exceptional dedication to this project and applaud the integrity and commitment with which

he has adhered to his concepts of high artistic standards in contemporary painting and sculpture.

The notion that the *Carnegie International* should be a great event for Pittsburgh and also ought to have a national and international tour was suggested to one of the Museum of Art's best corporate friends, Aluminum Company of America, long known for its belief in and support of the arts. We especially appreciate the support of W. H. Krome George, Chairman; George T. Haymaker, Jr., Vice President, International; and Charles L. Griswold, President, Alcoa Foundation. Alfred M. Hunt, Vice President and Secretary, and a Trustee of Carnegie Institute, has been a valued counselor and deeply appreciated friend of the project. Through Alcoa Foundation the exhibition received very generous support for its showings at the Museum of Art, Carnegie Institute and at the Seattle Art Museum. Alcoa of Australia Limited has contributed equally generously to make possible showings at the Art Gallery of Western Australia in Perth, the National Gallery of Victoria in Melbourne, and the Art Gallery of New South Wales in Sydney. We are grateful to the directors of the museums participating in the tour for their interest and cooperation: Arnold Jolles in Seattle, W. Frank Ellis in Perth, Patrick McCaughey in Melbourne, and Edmund Capon in Sydney. The International Cultural Corporation of Australia Limited, and its Executive Director, Robert Edwards, organized the Australian tour with the Art Gallery of Western Australia in the role of lead institution. We have very much enjoyed this collaboration with our Seattle and Australian colleagues.

The list of individuals around the world who have contributed to the complex organization of this project is so long that we have included in this catalogue a page of acknowledgements and thanks. It is with special appreciation here, however, that we single out a number of members of the Museum of Art and Carnegie Institute's staffs who have played key roles in carrying out the project: Barbara L. Phillips, Assistant Director for Administration; Ripley F. W. Albright, Consulting Exhibition Assistant; Ann S. Blasier, Exhibitions Coordinator; Charles W. Cathey, Registrar; Dr. Vicky A. Clark, Curator of Education; and Mary C. Poppenberg, Director of Public Relations. Frank Garrity designed the catalogue and the exhibition's distinctive graphics program. The Women's Committee of the Museum of Art, Jean M. George, President, and its *Carnegie International* Subcommittee, Ann P. Wardrop, Chairman, graciously and capably undertook the planning and supervision of many of the special events and much of the hospitality so importantly associated with the exhibition.

The *Carnegie International* has long been the most exciting and ambitious undertaking of the Museum of Art. We are fortunate to have found our own enthusiasm met at every quarter, most particularly from the lenders who have so generously parted with their works for the duration of the exhibition.

One of the joys of an exhibition of contemporary art is that the artists and not just their works are involved. We thank them for their participation and salute their accomplishments.

John R. Lane
Director

Acknowledgements

Argentina
Jorge Glusberg
Samuel Paz

Australia
Dr. Jeanne A. Battesby
Anthony Burgess
Edmund Capon
J. L. Diederich
Robert Edwards
W. Frank Ellis
James B. Leslie
Robert Lindsay
Elwyn Lynn
Hugh Matheson Morgan
Patrick McCaughey
Ronald Nolan
Sir Arvi Parbo
John Ridley
James M. Vann
Nick Waterloo

Austria
Wolfgang Dreschler
Thomas Nowothy

Belgium
Andrea Murphy

Brazil
Mark Berkowitz
Albert Bildner
Emidio Dias Carvalho
Helio Carvalho
Marilia Kranz
Thereza Miranda

Chile
Nena Ossa

Denmark
Mogens Breyen
Uffe Himmselstrup
Aase Hofmann
Jørgen Rømer

Finland
Ritva-Liisa Elomaa
Maaretta Jaukkuri
Paul Osipow

France
Patrice Bachelard
Tani Block

Germany
Katharina Schmidt

Ireland
Michael Warren

Japan
Yoshiaki Inui
Tamon Miki
Hitoshi Nakazato

Korea
Sunu Choi
Cheon Hoseon
Kim Jihyeon
Oh Kwang-Su
Se Duk Lee
Kim Seokho
Tak Yoon

Mexico
Diane Stanley

The Netherlands
Marijke Van Drunen Littel
Gijs Van Tuyl

New Zealand
Trevor Hughes
Betty Logan

Norway
John Bjørnebye
Ole Henrik Moe

Portugal
Luis de Sousa

South Africa
William Ainslee

Spain
Roberto Bermudez
Miren De Bustinza Prats
José Luis Rosello

Sweden
Olle Granath
Lena Lofstradt
Jarn Springfeldt

United States
Juanita Perez-Adelman
Sarah B. Adkins
Ripley F. W. Albright
Directors of Alcoa Foundation
Ralph J. Barnhart
Irma Barr
Joseph C. Bates
Rosanne Bechtold
Martha Bell
Mary C. Bencke
Joanne C. Benedict
Mernie Berger
Tessie Binstock
Ann S. Blasier
Huntington T. Block Insurance
Adriana Bond
Ann Boyd
Kristen Brown
Nancy Brown
Edwin J. Brueggman
Pamela Bryan
Ellen S. Cadman
Charles Cathey
Margaret Childs
Vicky A. Clark
Mary Ann Crecelius
Karen B. Crenshaw
Gabrielle Dinman
Barbara U. Dinsmore

Introduction

The ongoing communications revolution, with its emphasis on ever-faster information delivery, continues to shrink the world and even puts the remote planets as close to our armchairs as beer and pretzels. Our home computers balance our checkbooks, and our television sets make instantly available whole cities of shops where, soon, we will be able to spend our dollars by tapping a button. In the intimacy of the den or family room we become acquainted with domestic politicians and foreign statesmen and their problems and hear the anchorman interpret their words (and deeds) in terms anyone can understand. Everything is made easier for us as the electronic miracle edits human experience and substitutes the media event for the complexities of living. In this world, which costs so much a month to enter, there is no struggling for judgment.

The practical aspects of existence are standardized and otherwise disciplined by electronic machines and systems. Where the human spirit escapes is in the imperfect reflections of culture served up electronically. There, all is expansion, the world grown larger. The arts offer endless renewal, both of rational and irrational impulses. The pull of particular societies and individual histories does not make for a neat printout or a thirty-second summary. Detergent, yes; dance, no. In the arts taken worldwide, newness and strangeness are everywhere. The television set, the satellite, the high-speed printer, the recording tape, the many technologies of rapid imitations and reproduction have generated an unprecedented audience for culture. Who could have thought in saner days that the remains of King Tut, a minor Egyptian potentate, could have become a preoccupation of so many foot-weary Americans? Or that an Elvis Presley could outlive his sad demise to become a minor deity and a major industry of memorabilia?

Certainly superstar success of person, place, or thing is unthinkable without modern delivery systems—without the media—the concerted, insistent organs of publicity that declare the values and discover the fashions of the mass society. But in cultural matters control is more elusive, for convention and tradition, the vagaries and rigidities of the originating society, are at the heart of the matter and are not easily known or profoundly understood.

Nevertheless, this is not to minimize the centuries of cultural interchange, often by accident of slow accretions, whereby the myths, legends, and finally the literatures of a society impinged upon others. At a faster rate, it seems, musical influence has moved from society to society. Even dance, a rooted response to primordial forces, has elaborated its language to include fashions and conventions developed in times and places distant from particular origins. But these very dynamics, by which gross culture has migrated, add to the complexity of communication and interpretation. The result is a projection of culture as entertainment. The deep meanings that necessarily adhere to the sublime products of the human cultural mainstream become shallower and thinner the more we are diverted and pleased. A good time was had by all is not what Antigone or King Lear or Fidelio are really about, and their intrinsic meanings are not better served by electronic delivery.

Currently, the visual arts are the prime example of the broadest cultural dissemination through which internal meanings and

traditions are lost. There was never an interest in contemporary art to match that of our own time. There was never the broad availability of the arts of the past and of exotic societies that now exists. And yet what the public consumes beyond its casual experience of museums and art galleries is distortion of art, perversion of its aims, displacement of its meanings—not the real thing at all but a simulacrum.

The avalanche of art material generated by the media and the press direct public attention to imitations and reductions of real works. Slides, magazine photographs, works presented on television are all false in color and scale. The subtleties of surface, the integrity of brushwork to a consistent effect, true values and relationships of shape, the interaction of sculptural form with space, the energetic interaction of art with architecture—all of these qualities basic to an understanding of what we are seeing have become hostage to the limitations or characteristics of specialized non-art technologies.

What we see if we do not look at the art work itself but only at its reproduction, however cleverly achieved, is image. The graphic quality in art is pushed to the fore at the expense of every other artistic concern. But even the graphic presentation the media affords compromises our perception. Picasso's *Guernica* on a postcard, though untold numbers may admire it, is not what the artist had in mind. And where perhaps there was less in mind to begin with we have the result of the commonplace image projected as an icon—Warhol's *Campbell's Soup Can,* Indiana's *Love.* Images such as these lend themselves to reproduction in a multitude of forms and sizes. The icon can become a scarf, a paperweight, a key ring bangle, a decal for your T-shirt—you name it, the possibility is there. Norman Rockwell's popular *Saturday Evening Post* cover illustrations are now available as soap at $3.75 a cake. You never lose the image until you have bathed or showered it away, but when do you lose the art?

Allegedly the media present success. What would Jackson Pollock's career have been without the assistance of *Life* magazine? There is no doubt that the stories of the stars helped to make the stars and to hold them in the firmament of public attention. I am not, of course, denigrating Pollock's achievement, but only pointing out that a long silence would have served him ill and certainly would have changed public interest in contemporary abstraction.

Today, we think of art as being delivered by the decade—a painter of the sixties, a sculptor of the seventies—as if everything that artists struggle to achieve over a lifetime were so easily disposed of in the turn of a decade. What was Rembrandt an artist of? How compress his career? Or Michelangelo's? Or Titian's, who had the bad taste to paint brilliantly in old age?

And if the media are not playing this particular game, they present art as tending toward some theoretical perfection. The artist to remain currently in vogue must always surpass his last exhibition. But this is often a matter of commanding more media attention, more articles, more interviews, more of everything that keeps public interest alive—sensitivity not to art quality but to star quality.

Another aspect of the management of the attention of an art-conscious public is media presentation of art as discrete movements: Abstract Expressionism, Op Art, Pop Art, Minimal Art, Conceptual Art, Post-Modernism, Stupid Art, the New Wave, Pattern Art, the New Realism, the New Expressionism. No doubt I've not put these in proper order, but the message is clear; novelty, newness, strangeness are forces of progress (and market forces). This is an approach delectable to the fashion-conscious, for it allows them to be avant-garde by consuming whatever is at the moment presented, abandoning all that went before. Art becomes a conversation piece, a smart new possession, whether it is possessed physically or not. The satisfaction is in one's sophistication, in the sense of being with it, a person of special perceptions.

The fact is the visual arts comprehend the many movements and variations that lie within its concerns. These coexist, whether labeled or not. They are seldom movements in any organized way and more often involve artists of very different character who are struggling with broadly analogous problems. The Abstract Expressionists were in no sense a group, and today's New Realists offer a gamut of responses ranging from pedestrian illustration to baroque invention. These days anyone is a Realist who paints a recognizable object. Most important, temporary emphasis upon one mode of visual expression does not invalidate the many that remain for the moment quiescent or unobserved.

A difficulty is that we seem to have given over any concern for the relationship of the art of the present to that of the past. The world's museums are full of materials that speak to an ongoing tradition of realism, often of great force and beauty, but this work of the past never enters breathless presentation of the art of the present. It is as if art were invented in the last few weeks or months. The past, when it does appear in the art press or on television, is more apt to be buried in anecdote or given some other sort of literary emphasis. The art of the past is almost never dealt with visually, as if it could not truly be what it is, a living source for today's artists.

Cut off from the sense of the artistic past's vitality, both the public and the young aspiring artist are condemned to the present, condemned to a standard of success that does not necessarily involve quality. The rush to approval focuses on mere worldliness. The badges of choice are economic success and an admission to the company of art professionals.

In fact, the tasks of artists are always the same. They must discover what is uniquely theirs in visual perception and position it relative to artistic convention without a self-defeating idiosyncracy. The position may be pro or con, may be radical in many senses, but must always bear the possibility of clarification through time and public experience of the work. In short, artists must make the public see in their own peculiar ways, through tenacity and repetition as much as through inventiveness. This is a different approach to the one now prevailing, where the art student searches the magazines and galleries for images adaptable to economic success, to the making of yet another sanctioned art product. With this emphasis, repetition becomes a form of manufacturing and tenacity a form of marketing.

It is dismaying that so many museums, art institutions, and collectors are now in the business of manufacturing art objects that imitate works of quality. The public is encouraged to buy reproductions that are out of the scale declared by the originals and often differ from their models in so many particulars as to corrupt the taste and judgment of the buyer. The pool of money available for the purchase of art does not increase when false is offered for true. People simply buy fewer original works when reproductions are approved by the art community as acceptable art substitutes. Now, anyone with the wherewithal can own something that looks more or less like an original once owned by Governor Rockefeller, whose fine collection did not lack for publicity.

Museums and public collections are legitimate to the extent that they display original works of art sustained by abiding standards of quality. They may concentrate upon a narrow excellence or may shape their collections to inclusive social and educational ends, but they must make art available for viewing. There is no substitute for the direct experience of art, nothing that educates the eye better than looking at original work, nothing that shapes the sensibility of the viewer more truly and opens for him or her the infinite possibilities presented through artistic visions, modes of seeing, and perceptual laws. Some would argue that the best results are obtained in the most neutral environment, where the viewer and art object exist without external distractions. Others hold that support systems are necessary; for instance, to convey a sense of the past, period furniture and objects of virtu might be added to what is essentially a display of painting and sculpture. Some institutions rely upon audio-visual aids, elaborate wall texts, and similar educational devices. Certainly, catalogues are primary interpretive material. But whatever method to enhance the interaction of art with viewer is employed the visual strength or weaknesses of the work are finally at issue. Art may have the rich iconographic detail that delights the art historian; it may speak to history, philosophy, religion, and humanistic values, but sheerly visual manipulations of the artist are what produce effectiveness in the delivery of extra-visual elements in art. How the painter handles paint, both as an individual and as a member of a culture with artistic traditions, how the sculptor deals with material, mass, space, and involves his work with the integuments of air and light, make possible our appreciation of his efforts and insights.

We must concede that museums and public collections, despite the often sensitive efforts of professional staff, remain imperfect places for the viewing of art. The building itself may be hostile. The traffic patterns may create busyness that defeats contemplation. The struggle for mere numbers of visitors, an important element in fund-raising, may favor the blockbuster exhibition to the detriment of our appreciation of the basic collection. The desire on the part of funding agencies both public and private to present their boards with large-scale successes often squeezes out the truly new and genuinely experimental. The modest exhibition may be more difficult to fund and mount than the grand display.

Those of us who have visited museums know how little time there is to explore their fantastic resources. It requires discipline—great discipline, I may say—on the part of the visitor and even on the part of the museum professional to be comfortably familiar with

the contents of a great museum. And it is difficult for the visitor, on another level, to summon the concentration in an environment of distracting activity, to know a few works thoroughly, to find the answer to the questions, "What am I seeing? Why is this work affecting me the way that it is?" The wrong question, of course, is the staggering irrelevancy, "Do I like it?" This last is the commodity approach to art, the merest pause before the question, "Will it match the drapes?"

Coming to terms with a work of art confers a deeper pleasure than judging it. Understanding is the reward of the hard work of looking. To extract from a work of merit all that the artist has intended to communicate is hard and joyful work. Artists, after all, mark out a territory that we must re-explore, even in some sense reinvent. Critical principles follow from the art, seldom precede them except in terms of an arid academicism. Joshua Reynolds could to some degree injure Thomas Gainsborough's career by belaboring Gainsborough with his superior principles, but he could not make him paint less well or deny Gainsborough's stamp to all that he did.

As the media more and more establish in the public mind images and stories of art rather than art itself, it becomes more important —even critical—for museums and public collections to exhibit the thing itself. The rationale is quality, so that the public may liberate its reactions in educating its eyes. Exhibitions such as the *Carnegie International* are of interest principally because they bring together from the world at large paintings and sculpture of serious intent that might otherwise remain local in the most restrictive sense or that would be available primarily through the illusionistic presentations of the media. The *Carnegie International*, which dates back to the last century as a continuing presentation of art from many lands, and looks forward to the next century as well, need not pretend to definitiveness. What is desired instead by the organizer and museum administration is that the succeeding exhibitions in the series shall make interesting new art available in Pittsburgh and elsewhere, and provoke a dialogue, or even a monologue, about where quality in art lies. If such an exhibition is successful it will be possible to look at its contents five or ten years hence without remorse or shame. The attachment of the artists represented will be to the enduring traditions of art, to the conventions that allow us to understand artistic language of past and present, and not to mere novelty or idiosyncracy.

In an exhibition such as the *Carnegie International*, works too must speak to one another, the art of different lands partaking of a visual language understandable to all. The art must respect itself and not denigrate or cheapen its visual authority. It must not make a fetish of energy or assign artistic merit to triteness and willfulness.

In organizing this exhibition I have avoided much art that has been fashionably overexposed. In any case the new superstars, puffed by media hype, are scarcely to be avoided. A vast mass production seems somehow to have engulfed the museums and galleries of Europe and America, the sort of revolution that might have been fomented by first-year art students had they thought of it first. Instead, I have looked at the work of certain older artists who continue to work with vigor and authority, essentially labelless

masters, liberated from movements and decades alike. I have looked to artists at mid-career for the sharpening of their visual acuity, for the integrity and continuity of their efforts. And, of course, to the young who seem to be making their way toward a meaningful individuality.

The organizer traveled many, many thousands of miles and looked at far more art of merit in various places than could possibly be included in a single exhibition. In a number of instances, it was impossible to have work that one might have preferred. The practical consequences of prior commitments sometimes interfered. Many practical concerns exerted their pressures, so that this exhibition—as indeed any exhibition of size—is a compromise, a compromise nevertheless sensitive to local conditions and standards of artistic value.

Despite the great international growth of interest in the visual arts, particularly contemporary art, there remains in the many countries visited the dominating pressure of the local situation. We live in a country where appreciation for the visual arts is widespread and where support is available, if not always readily forthcoming. In other societies the visual arts are less advantageously placed in the public consciousness, less supported even when more admired. Government policy may make the mere tools of artistic production—modern tools—fine papers, good canvas, professional quality paints and the various supporting technologies—all but financially prohibitive. In other societies, many collectors may prefer imitation examples of the School of Paris or the School of New York to painting and sculpture that draws its strength from local sources or from national history. The reverse may be true elsewhere. Appreciation will be confined to a few minor figures nevertheless celebrated locally as masters. Official art is promoted in some societies; one is steered to the studios of those politically beyond reproach. Again, the reverse is true other places; artists will not have found a way to position themselves aesthetically or politically amid the conflicting claims of right and left. The scene will present a directionless confusion and conflict of aims.

The past too can be a great inhibitor; the more glorious the commanding tradition, the more difficult it is for the contemporary artist to find individuality in its shadow. The power to absorb meaningful influences from abroad, even to yield to the imagery of the art press or the television screen, may be frustrated by the lack of a local art market. Contemporary art, though produced everywhere, is not necessarily bought everywhere, so that a whole society of artists may depend upon teaching posts and government bursaries. One climbs this ladder of acceptance painfully, rung by rung. Wait long enough, behave yourself, and you will be asked to join the powerful boards and committees in your time. Elsewhere, everything is permitted and much is supported by public and private money that lacks consistent standards of quality. There, what the artist does is thought to be validated because he or she *is* an artist. Artists do what they like and are rewarded in proportion to their indiscipline.

A few times the organizer was astonished to find art of high quality produced in remote places by a practitioner who had no broad experience of foreign art but discovered discipline and vision, as it were, internally. No amount of copying from magazines

or looking at art books or watching the tube can yield such effects. The rediscovery that art in its serious aspect is a universal and mysterious phenomenon rewards the organizer especially. That art speaks to art, despite the clamor of the marketplace, promises well to any person who wishes to commit to its study and its joys.

At the same time, we must understand that the visual arts of the present period are mainly barren of significant innovation. The most popular labels of the moment seem committed to an art that is retrograde. The New Realism looks backward but not to the best that is available. Pattern Art has largely ignored impressive sources that stretch around the world in the decorative impulses of whole ages and diverse societies. With these painters, the posture of innocence seems only negligent. New Wave Art and the New Expressionism are even more tenuously and trivially connected to the sources they profess. They represent a tradition thrown away.

Out of favor, the painters concerned primarily with the operations of color still produce work of power and authority, but it is scarcely noticed, its worth ignored. The ancient tradition of sculpture in bronze, wood, and stone reasserts itself at the expense of welded steel sculpture growing ever more academic and spiritless. Promising, too, is a romantic figuration that is personal and unprogrammatic and is to be found having its different and interesting say in many places around the world. The highly personal solution seems, after all, to have attracted the most promising artists and to have sustained the most accomplished ones.

Technology, too, has been used more personally in recent times. There is not so much the mark of the factory on things. Anonymity of surface has given way again to the personal mark. There is quite clearly in much contemporary work, whether one finds it in Japan or Australia, in South Africa or Scandinavia, an impulse unafraid of craftsmanship and of the artist's personal intervention in what is made. In many instances, a roughness results from these manipulations, less sophisticated and barbered manipulation of a visual idea that might have been expected a decade or two ago. A subtle shift in attitude appears in many artists to have revived their interest in medium, in the ways of dealing with materials, in the broad range of techniques available to painter and sculptor. This is perhaps a counterweight to all the casual paint-slopping and bad welding that has been celebrated in the chief art markets over the past several years.

The present *Carnegie International,* then, does not represent a movement or an excursion into critical polemics. As an exhibition, it seeks to balance tendencies and to look at work from distant places that have things to say each to the others. It deals with correspondences among individual efforts, not because the artists belong to a club, but because they share concerns and attitudes that are essentially visual and that are based upon a knowledge of medium and a respect for its possibilities. The organizer has looked not for images but for presences, for art that does not give everything up at once, but that retains resonance to challenge us or stimulate us anew at repeated encounters.

This exhibition seeks to remind visitors of the skills that artists display in their work and asks that they take pleasure in the artistic side of art—forbearing to despise superiority of facture and all the other niceties that have distinguished the visual arts through the ages. There has been no determination on the part of the organizer to brutalize tradition or to assert that art, to be contemporary in spirit, must deny its aesthetic dimensions. We're not in pursuit of the beautiful, but we're not afraid of it either.

An important concern has been to bring the active viewer back to life. Much modern art has required the interaction of person and object—the kind of communication that involves all of the psycho-physical forces at our disposal. The exhibition invites you to give energy to, and receive it from, the objects contemplated. The media have rendered the viewer passive and have denied him the power to reach out toward understanding and judgment. The exhibition seeks to redress the balance and to release powers of perception—had by all of us without benefit of anyone's approval.

Gene Baro

Color Plates

Jeffrey Harris
Untitled (Judith) No. 4,
1978-79
oil on hardboard
47¼ x 70³⁄₁₆ in.
(120 x 178.2 cm.)
Lent by the artist, courtesy of
Bosshard Galleries, Dunedin,
New Zealand
(catalogue no. 61)

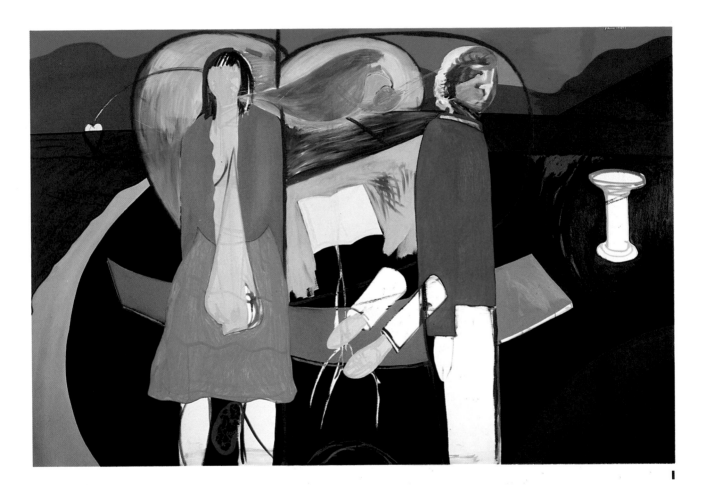

II Milan Mrkusich
Monochrome Blue,
Four Areas, 1979
acrylic on cardboard
46¾ x 48¼ in.
(118.7 x 122.5 cm.)
Lent by the artist, courtesy of
Bosshard Galleries,
Dunedin, New Zealand
(catalogue no. 115)

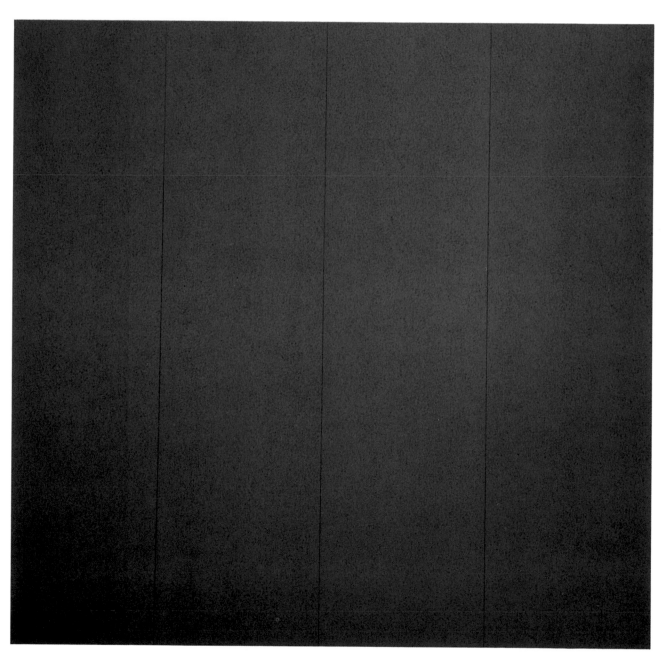

III John Hoyland
Hoochy-Coochy, 1982
acrylic on canvas
100 x 90 in.
(254 x 228.6 cm.)
Courtesy of Jacobson/
Hochman Gallery, New York
(catalogue no. 72)

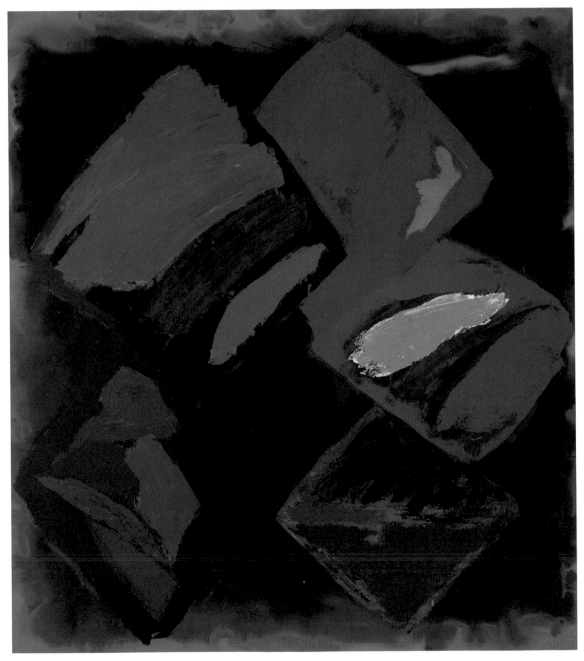

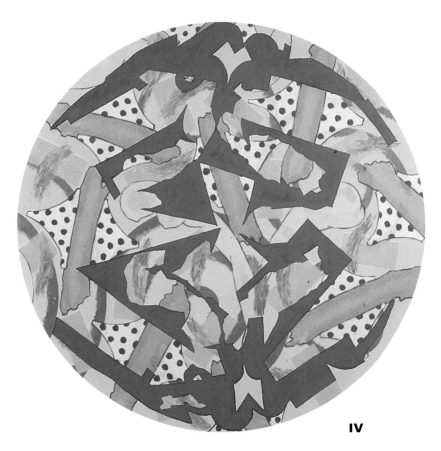

IV Olle Kåks
Narcissus, 1981
oil on linen
Diameter 65 in.
(165 cm.)
Lent by the artist
(catalogue no. 82)

V Michael Shannon
*Yarra from Johnston Street
Bridge,* 1979
oil on canvas
36 x 72 in.
(91.5 x 183 cm.)
Lent by the artist, courtesy of
Powell Street Gallery,
Melbourne
(catalogue no. 146)

IV

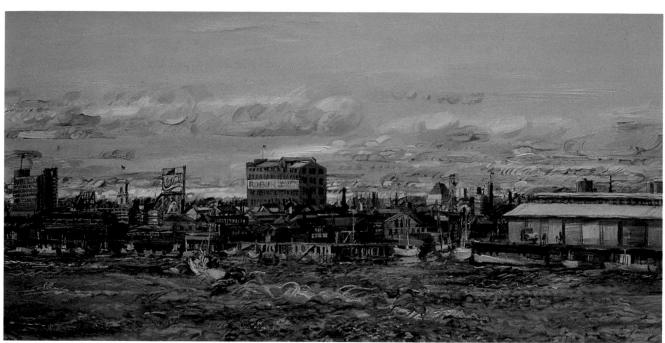

V

VI Claudio Bravo
*The Guardian and
His Son,* 1979
oil on canvas
94⅝ x 78¾ in.
(240.3 x 200 cm.)
Courtesy of Marlborough
Gallery, New York
(catalogue no. 22)

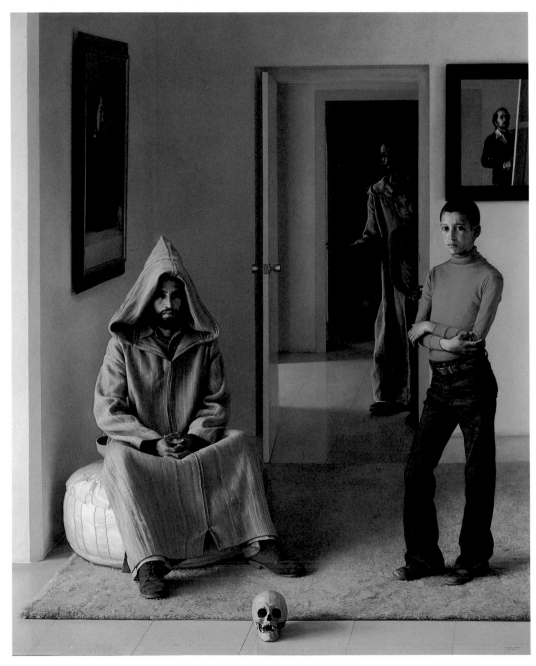

VII Chema Cobo
King Midas, 1981
acrylic on canvas
78¾ x 118⅛ in.
(200 x 300 cm.)
Courtesy of Galería Fernando
Vijande, Madrid
(catalogue no. 26)

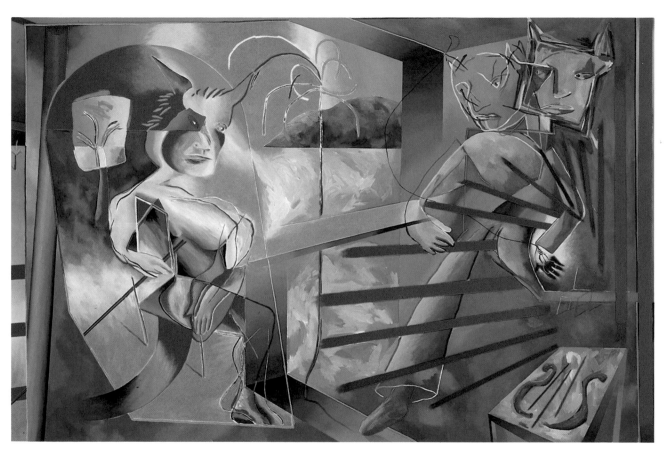

VIII Antonio Sergio Benevento
Landscape in Spiral, 1979
acrylic on canvas
47¼ x 51³⁄₁₆ in.
(120 x 130 cm.)
Lent by the artist
(catalogue no. 10)

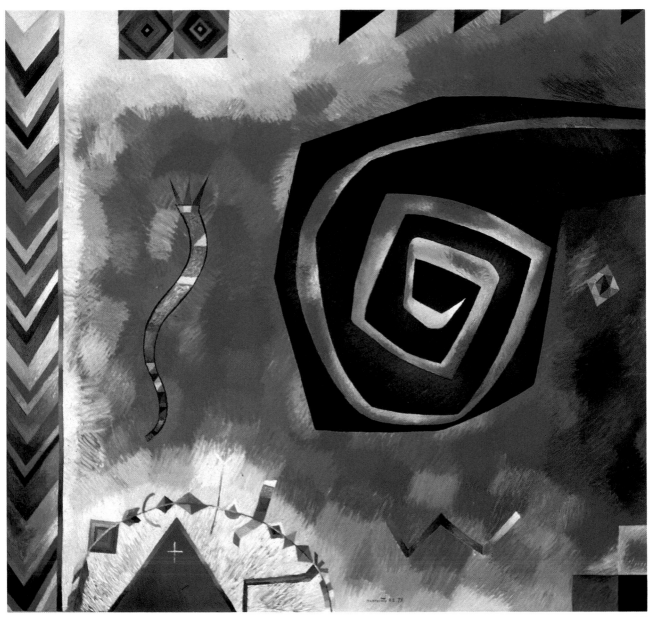

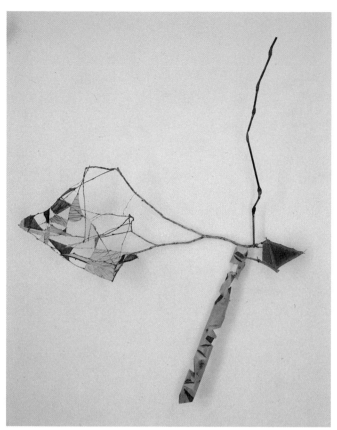

IX

IX Yoshio Kitayama
They Are Innocently in the World Together, 1981
wood, copper, leather, paper, and bamboo
54¾ x 68⅛ x 21¹¹/₁₆ in.
(139 x 173 x 55 cm.)
Courtesy of Galerie 16, Kyoto
(catalogue no. 90)

X Piero Dorazio
Carrera, 1979
oil on canvas
23¾ x 55 in.
(60.3 x 139.7 cm.)
Lent by the artist, courtesy of André Emmerich Gallery, New York
(catalogue no. 34)

X

XI David Hockncy
Outpost Drive, Hollywood,
1980-82
acrylic on canvas
60 x 60 in.
(152.4 x 152.4 cm.)
Lent anonymously
(catalogue no. 69)

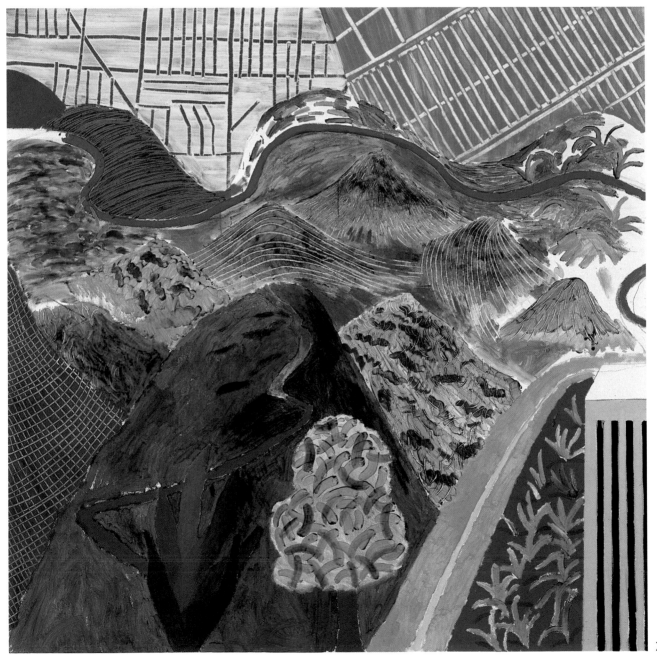

XII Nigel Hall
Shoal (large), 1982
painted aluminum
$93^{11}/_{16}$ x $41^{15}/_{16}$ x $10^{5}/_{8}$ in.
(238 x 106.5 x 27 cm.)
Courtesy of Juda Rowan
Gallery, London
(catalogue no. 60)

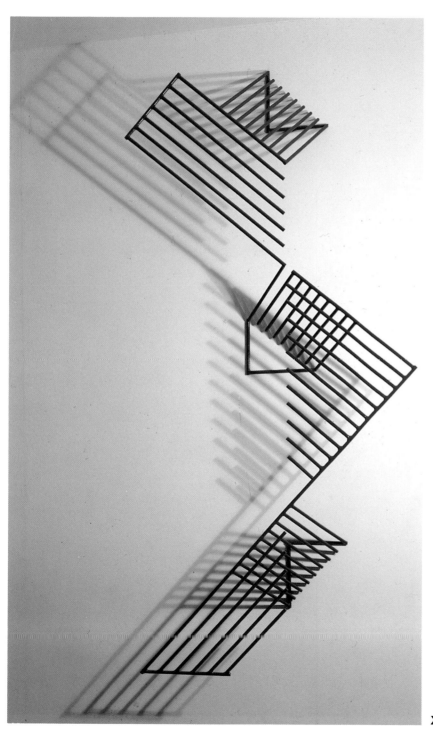

XIII Red Grooms
Western Eagle, 1980
painted bronze
36 x 19 x 32 in.
(91.4 x 48.3 x 81.3 cm.)
Courtesy of Marlborough
Gallery, New York
(catalogue no. 55)

XIV Lee Krasner
To the North, 1980
oil on canvas with collage
58½ x 64 in.
(148.6 x 162.6 cm.)
Courtesy of Robert Miller
Gallery, New York
(catalogue no. 96)

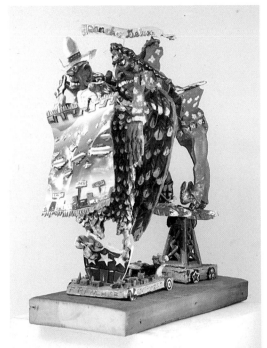

XIII

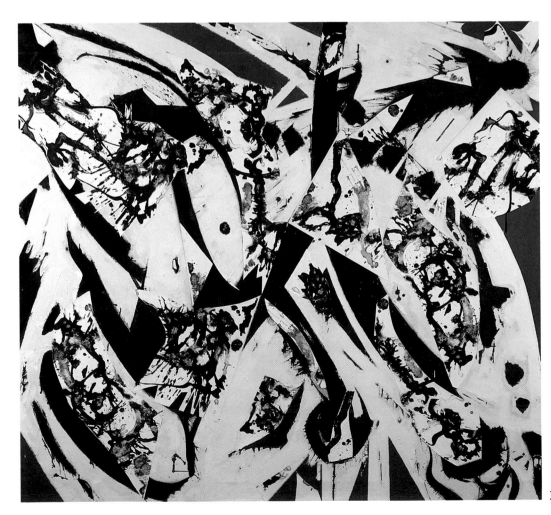

XIV

XV Ilona Anderson
The Werewolf Passion, 1981
acrylic on canvas
59¹/₁₆ × 71¼ in.
(150 × 181 cm.)
Lent by the artist
(catalogue no. 4)

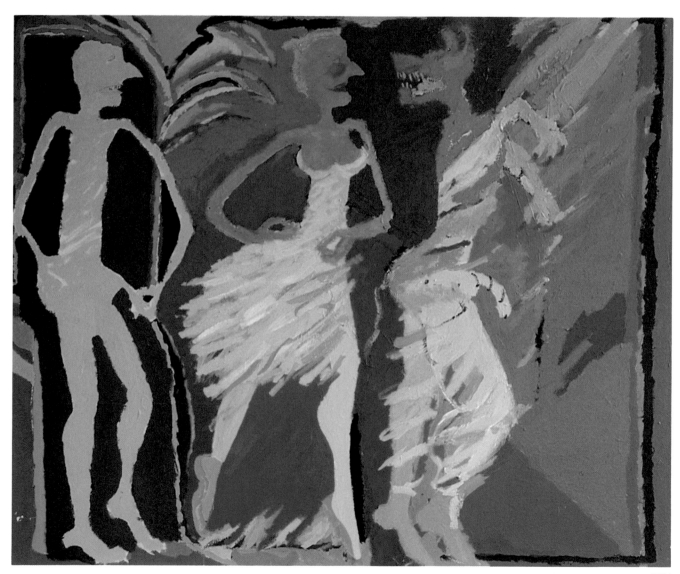

XVI Rackstraw Downes
*110th Street and Broadway,
Whelan's from Sloans,* 1981
oil on canvas
21¼ x 38⅛ in.
(54 x 96.8 cm.)
Courtesy of Hirschl and
Adler Modern, New York
(catalogue no. 37)

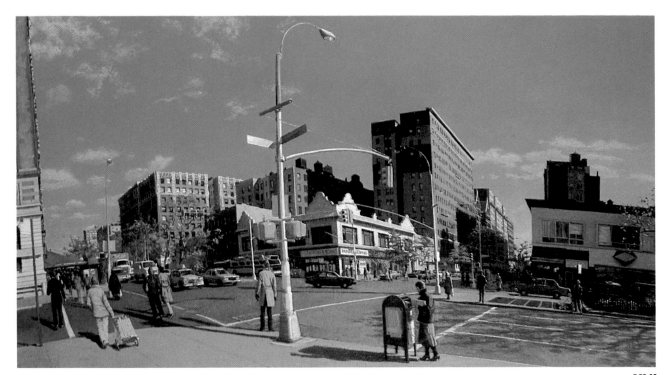

XVI

XVII

XVIII

XVII Judy Singer
Affection, 1981
acrylic on canvas
71 x 47½ in.
(180.3 x 120.7 cm.)
Lent by H. J. Heinz Company,
Pittsburgh
(catalogue no. 151)

XVIII Albert Stadler
Arcing Light, 1981
acrylic on canvas
79½ x 170½ in.
(201.9 x 433.1 cm.)
Museum of Art, Carnegie
Institute; The Henry L. Hillman
Purchase Fund 81.29.2
(catalogue no. 157)

XIX James McGarrell
Crossing Move, 1981-82
oil on canvas
78 x 59 in.
(198.1 x 149.9 cm.)
Courtesy of Allan Frumkin
Gallery, New York
(catalogue no. 110)

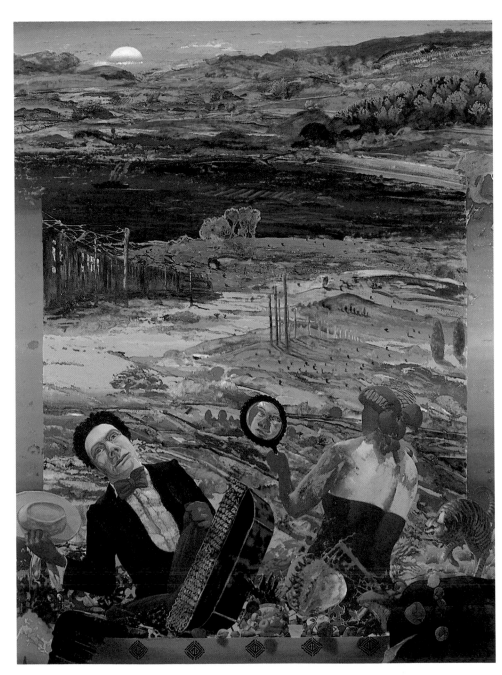

XIX

Catalogue

Sergi Aguilar
Spanish, born 1946
Currently working in Barcelona

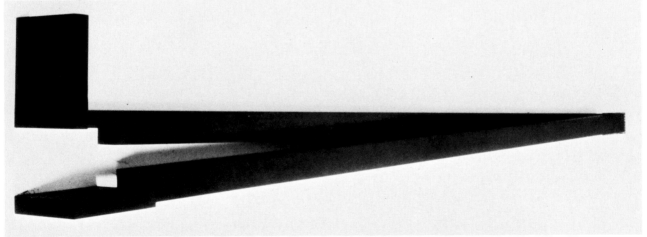

1

1 *Compás Angular,* 1980
iron
4¾ x 78¾ x 6⅞ in.
(12 x 200 x 17.5 cm.)
Courtesy of Galería Fernando
Vijande, Madrid

2 *Cran no. 3,* 1980
black Belgian marble
15 x 50 x 60 in.
(38.1 x 127 x 152.4 cm.)
Courtesy of Galería Fernando
Vijande, Madrid

3 *Posicion no. 9,* 1980
black Belgian marble
27 x 56½ x 30¾ in.
(68.6 x 143.5 x 78.1 cm.)
Courtesy of Galería Fernando
Vijande, Madrid

2

3*

Ilona Anderson
South African, born 1948
Currently working in
Johannesburg

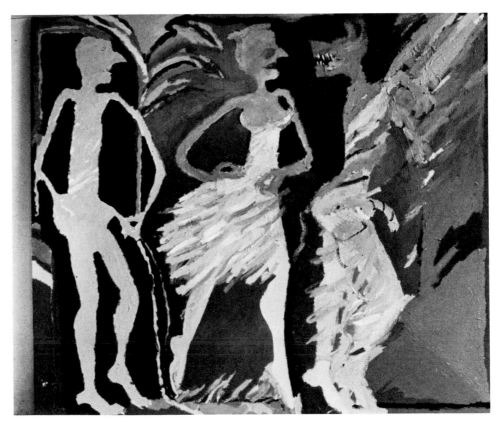

4

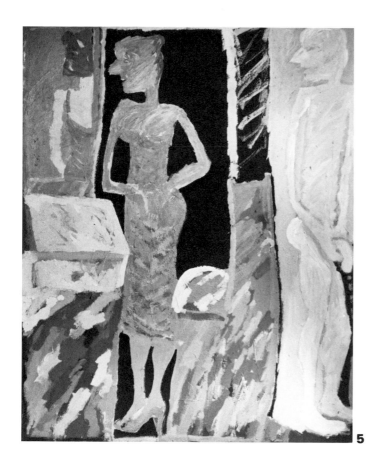

5

4 *The Werewolf Passion,* 1981
acrylic on canvas
59 1/16 x 71 1/4 in.
(150 x 181 cm.)
Lent by the artist
(Color Plate XV)

5 *Lady at Mirror,* 1981-82
acrylic on canvas
59 1/16 x 49 5/8 in.
(150 x 126 cm.)
Lent by the artist

6 *A Large Painting,* 1982
acrylic on canvas
67 5/16 x 91 3/8 in.
(171 x 232 cm.)
Lent by the artist

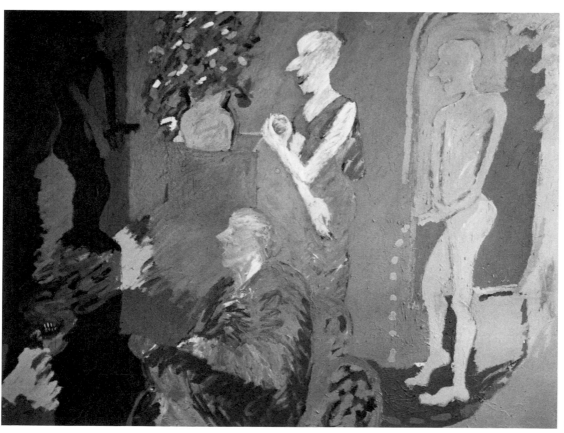

6*

Armando
Dutch, born 1929
Currently working in West Berlin

8

9

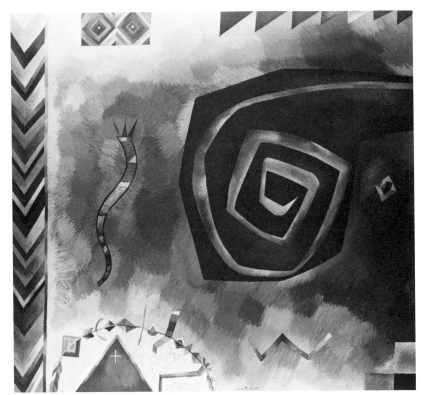

10

Antonio Sergio Benevento
Brazilian, born 1945
Currently working in
Rio de Janeiro

11

10 *Landscape in Spiral,* 1979
 acrylic on canvas
 47¼ x 51³/₁₆ in.
 (120 x 130 cm.)
 Lent by the artist
 (Color Plate VIII)

11 *Precocious Invasion,* 1980
 acrylic on canvas
 51³/₁₆ x 47¼ in.
 (130 x 120 cm.)
 Lent by the artist

12 *Fragments of a New World,* 1981
 acrylic on canvas
 63 x 47¼ in.
 (160 x 120 cm.)
 Lent by the artist

12*

13*

Max Bill
Swiss, born 1908
Currently working in Zurich

14

13 *system out of six similar rows
of color — forming a
pythagorean triangle,* 1978-82
oil on canvas
59 1/16 x 59 1/16 in.
(150 x 150 cm.)
Lent by the artist

14 *excentric rhythm 1:2:3:4,*
1980-82
oil on canvas
83 1/2 x 83 1/2 in.
(212 x 212 cm.)
Lent by the artist

15 *twelve groups of four
in the white field,* 1982
oil on canvas
59 1/16 x 59 1/16 in.
(150 x 150 cm.)
Lent by the artist

15

Christian Bonnefoi
French, born 1948
Currently working in Paris

16*

16 *Ephésiens,* 1980
acrylic on gauze
74¹³/₁₆ x 118⅛ in.
(190 x 300 cm.)
Courtesy of Galerie Jean
Fournier, Paris

17 *Untitled,* 1981
acrylic on gauze
103⅛ x 98⁷/₁₆ in.
(262 x 250 cm.)
Courtesy of Galerie Jean
Fournier, Paris

18 *Untitled,* 1981
acrylic on gauze
103⅛ x 98⁷/₁₆ in.
(262 x 250 cm.)
Courtesy of Galerie Jean
Fournier, Paris

17

18

Fernando Botero
Colombian, born 1932
Currently working in Paris

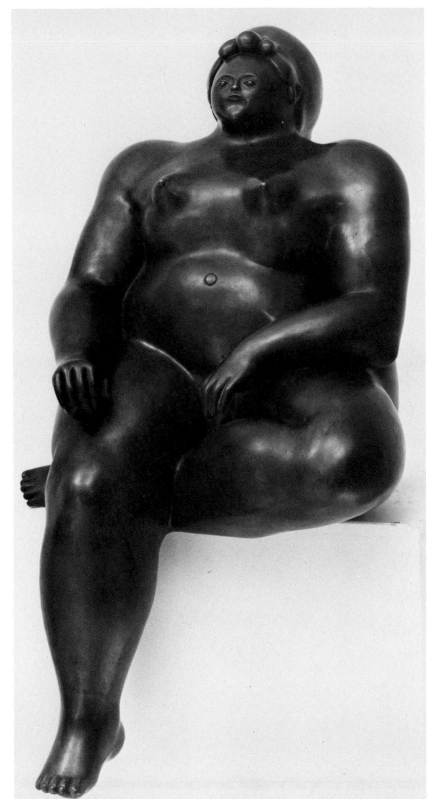

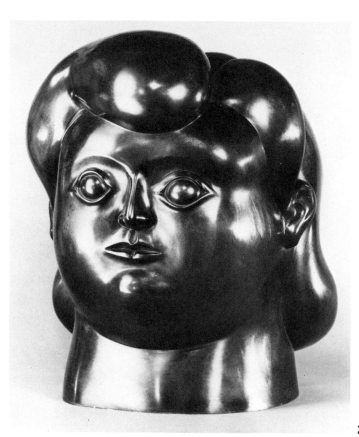

19 *Sitting Woman,* 1976-80
bronze
46½ x 31½ x 28⅜ in.
(118.1 x 80 x 72.1 cm.)
Courtesy of Marlborough Gallery,
New York

20 *Head of a Woman,* 1981
bronze
16 x 12 x 14 in.
(40.6 x 30.5 x 35.6 cm.)
Courtesy of Marlborough Gallery,
New York

21 *Man on Horseback,* 1981-82
bronze
13⅞ x 7¼ x 10¾ in.
(35.2 x 18.4 x 27.3 cm.)
Courtesy of Marlborough Gallery,
New York

20*

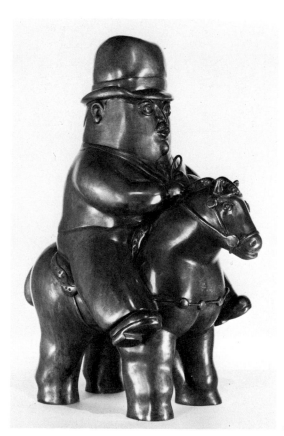

21

Claudio Bravo
Chilean, born 1936
Currently working in
Tangier, Morocco

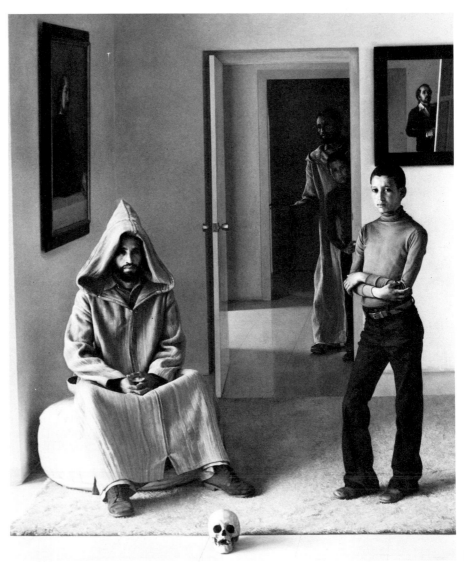

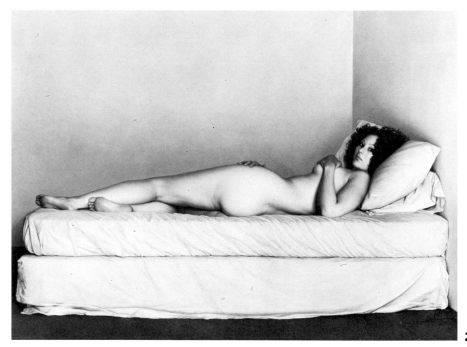

23*

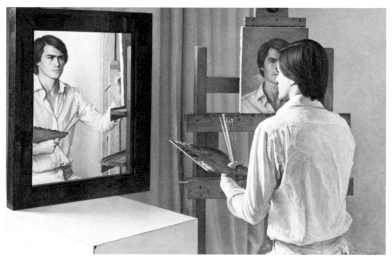

24

22 *The Guardian and His Son,* 1979
oil on canvas
94⅝ x 78¾ in.
(240.3 x 200 cm.)
Courtesy of Marlborough Gallery,
New York
(Color Plate VI)

23 *Venus,* 1979
oil on canvas
59¼ x 78⅞ in.
(150.5 x 200.3 cm.)
Courtesy of Marlborough Gallery,
New York

24 *Rafael,* 1980
oil on canvas
37⅜ x 57 1/16 in.
(95 x 145 cm.)
Lent anonymously

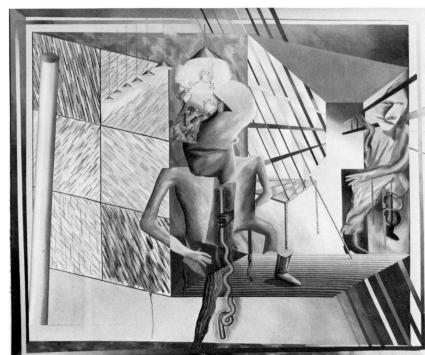

25 *

Chema Cobo
Spanish, born 1952
Currently working in Tarifa, Spain

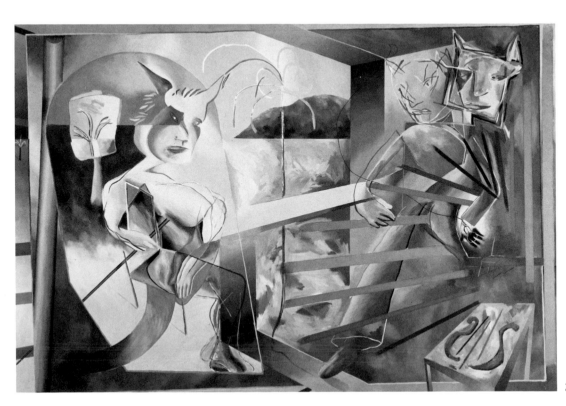

26

25 *Electricman que mira
la lluvia,* 1980
acrylic on canvas
70⅞ x 82¹¹/₁₆ in.
(180 x 210 cm.)
Courtesy of Galería Fernando
Vijande, Madrid

26 *King Midas,* 1981
acrylic on canvas
78¾ x 118⅛ in.
(200 x 300 cm.)
Courtesy of Galería Fernando
Vijande, Madrid
(Color Plate VII)

27 *Family Plot,* 1982
acrylic on canvas
77 x 131 in.
(195.6 x 332.7 cm.)
Courtesy of Galería Fernando
Vijande, Madrid

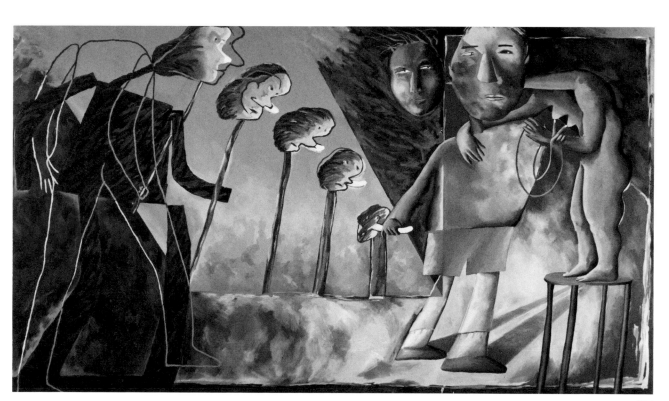

28*

Bernard Cohen
British, born 1933
Currently working in Kew, Surrey

29

28 *Home Territory,* 1977-79
acrylic on linen
54 x 66 in.
(137.2 x 167.6 cm.)
Courtesy of Waddington Galleries,
Ltd., London

29 *Seven Places,* 1977-79
acrylic on linen
36 x 72 in.
(91.4 x 182.9 cm.)
Courtesy of Waddington Galleries,
Ltd., London

30 *Mythologies II — Imitations,*
1979-80
acrylic on canvas
72 x 72 in.
(182.9 x 182.9 cm.)
Courtesy of Waddington Galleries,
Ltd., London

30

Jorge Demirjián
Argentinian, born 1932
Currently working in
Buenos Aires

32

31 *Great Nude,* 1979
 oil on canvas
 38³/₁₆ x 63¾ in.
 (97 x 162 cm.)
 Lent by the artist, courtesy of
 Arte Nuevo, Galería de Arte,
 Buenos Aires

32 *Portrait of Marcos Curi,* 1981
 oil on canvas
 53⅛ x 39⅜ in.
 (135 x 100 cm.)
 Lent by the artist, courtesy of
 Arte Nuevo, Galería de Arte,
 Buenos Aires

33 *Woman in Red,* 1981
 oil on canvas
 33½ x 37⅜ in.
 (85 x 95 cm.)
 Lent by the artist, courtesy of
 Arte Nuevo, Galería de Arte,
 Buenos Aires

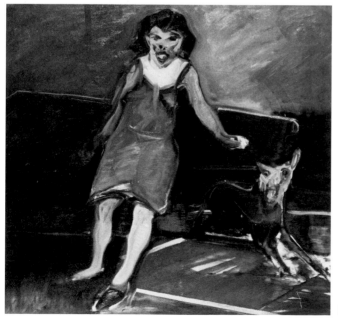

33

Piero Dorazio
Italian, born 1927
Currently working in Podi, Italy

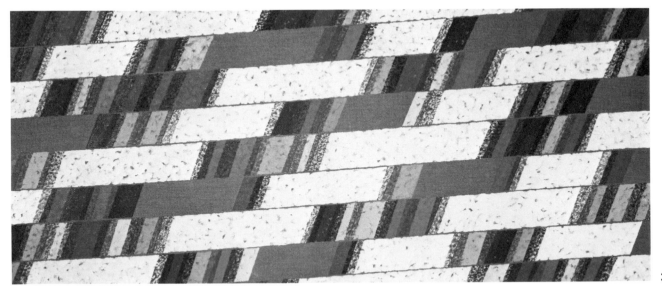

34*

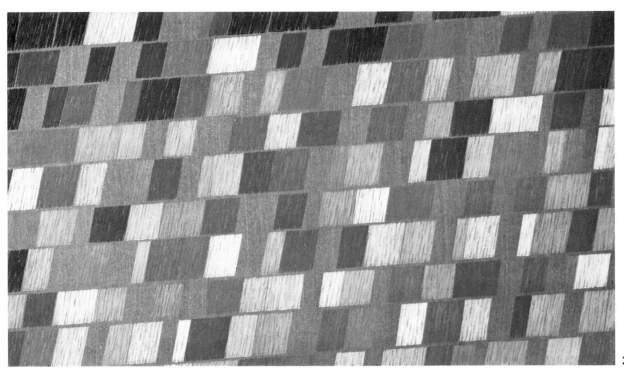

35

36

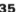

34 *Carrera,* 1979
oil on canvas
23¾ x 55 in.
(60.3 x 139.7 cm.)
Lent by the artist, courtesy of
André Emmerich Gallery,
New York
(Color Plate X)

35 *Elites,* 1980
oil on canvas
29½ x 43⁵/₁₆ in.
(75 x 110 cm.)
Lent by the artist, courtesy of
André Emmerich Gallery,
New York

36 *Physis II,* 1980
oil on canvas
17¾ x 27⁹/₁₆ in.
(45 x 70 cm.)
Lent by the artist, courtesy of
André Emmerich Gallery,
New York

Rackstraw Downes
American, born England, 1939
Currently working in New York
City and Freedom, Maine

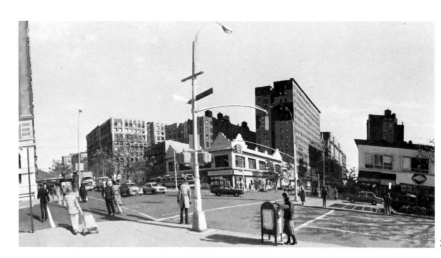

37

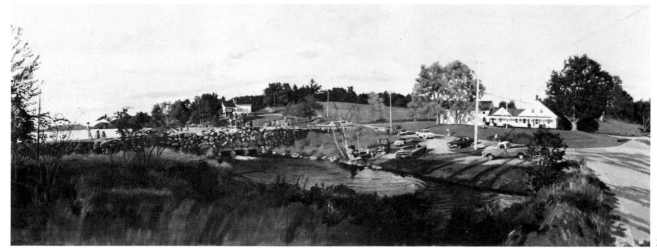

38

37 *110th Street and Broadway,*
Whelan's from Sloans, 1981
oil on canvas
21¼ x 38⅛ in.
(54 x 96.8 cm.)
Courtesy of Hirschl and
Adler Modern, New York
(Color Plate XVI)

38 *The Dam at Swanville,* 1982
oil on canvas
18½ x 47 in.
(47 x 119.4 cm.)
Courtesy of Hirschl and
Adler Modern, New York

39 *The East River with*
Gracie Mansion and
the Triborough Bridge, 1982
oil on canvas
17 x 60⅛ in.
(43.2 x 152.7 cm.)
Courtesy of Hirschl and
Adler Modern, New York

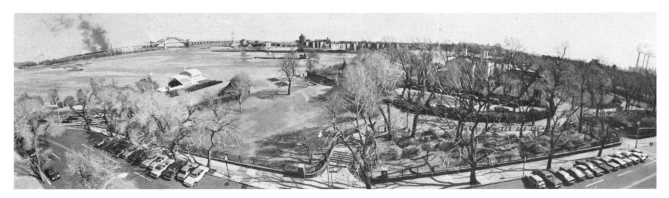

39*

Jean Dubuffet
French, born 1901
Currently working in Paris

40*

41

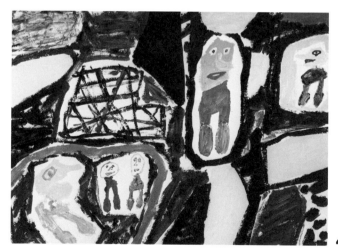

42

40 *Les environnés,* 1979
acrylic on paper with
collage mounted on canvas
27½ x 60¼ in.
(69.9 x 153 cm.)
Courtesy of The Pace Gallery,
New York

41 *Temps meles,* 1979
acrylic on paper with
collage mounted on canvas
27½ x 43 in.
(69.9 x 109.2 cm.)
Courtesy of The Pace Gallery,
New York

42 *Psycho Sights,* 1981
acrylic on paper mounted
on canvas
20 x 27½ in.
(50.8 x 69.9 cm.)
Courtesy of Richard Gray Gallery,
Chicago

Jennifer Durrant
British, born 1942
Currently working in London

43

43 *Souls I Missing,* 1980-81
acrylic on canvas
102½ x 121¼ in.
(260.4 x 308 cm.)
Courtesy of Nicola Jacobs
Gallery, London

44 *Head Over Heels,* 1981
acrylic on canvas
102½ x 118 in.
(260.4 x 299.7 cm.)
Courtesy of Nicola Jacobs
Gallery, London

45 *On the Way,* 1981
acrylic on canvas
101½ x 126 in.
(257.8 x 320 cm.)
Courtesy of Nicola Jacobs
Gallery, London

44*

45

46

Johannes Geccelli
German, born 1925
Currently working in West Berlin

47*

46 *Licht-Nicht,* 1979
acrylic on canvas
39⅜ x 35⁷/₁₆ in.
(100 x 90 cm.)
Courtesy of Galerie Suzanne
Fischer, Baden-Baden

47 *Ein-Aus,* 1981
acrylic on canvas
diptych, panel I—78¾ x 39⅜ in.
(200 x 100 cm.)
panel II—78¾ x 70⅞ in.
(200 x 180 cm)
Lent by the artist

48 *Rotstand,* 1982
acrylic on canvas
59¹/₁₆ x 39⅜ in.
(150 x 100 cm.)
Lent by the artist

48

Luis Gordillo
Spanish, born 1934
Currently working in Madrid

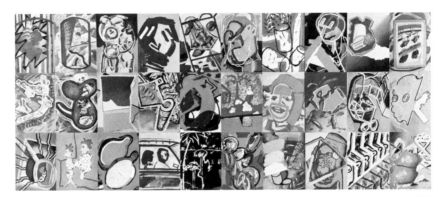

49

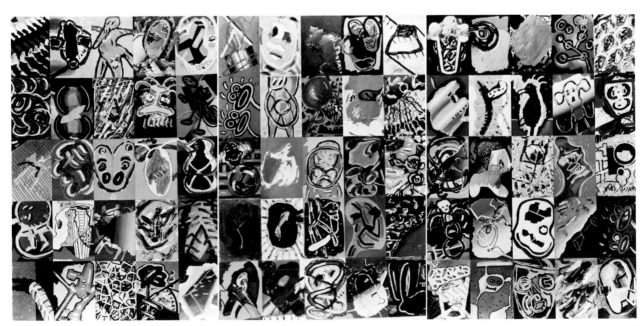

50

49 *3 x 10 con busto griego,* 1981
acrylic on cardboard mounted
on plywood
47¼ x 110¼ in.
(120 x 280 cm.)
Courtesy of Galería Fernando
Vijande, Madrid

50 *3 (5 x 5) serie fria A, B y C,* 1982
acrylic on cardboard mounted
on plywood
triptych, 61⅝ x 126⅜ in.
(156.5 x 321 cm.) overall
Courtesy of Galería Fernando
Vijande, Madrid

51 *Primera serie roja A, B y C,* 1982
acrylic on cardboard mounted
on plywood
triptych, 61⅝ x 126⅜ in.
(156.5 x 321 cm.) overall
Courtesy of Galería Fernando
Vijande, Madrid

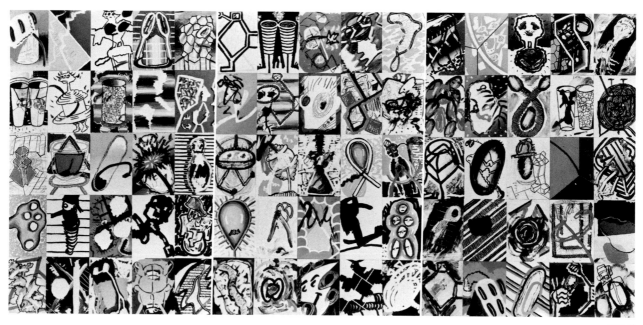

Gotthard Graubner
German, born 1930
Currently working in Düsseldorf

52 *Diptych (blue-violet/blue),*
1979-80
oil and acrylic on canvas
diptych, each panel 94½ x 94½ in.
(240 x 240 cm.)
Lent by the artist, courtesy of
m Bochum, Bochum,
West Germany

53 *Green Painting,* 1981
oil and acrylic on canvas
78¾ x 51³/₁₆ in.
(200 x 130 cm.)
Lent by the artist, courtesy of
m Bochum, Bochum,
West Germany
(not illustrated)

54 (not illustrated)

52*

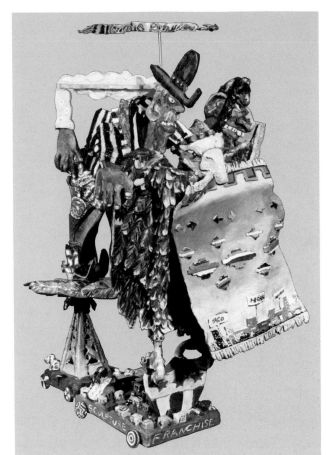

55

Red Grooms
American, born 1937
Currently working in New York

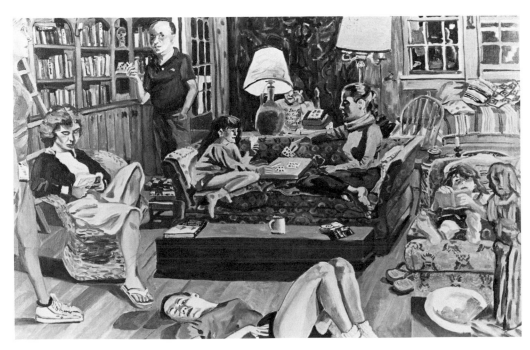

56*

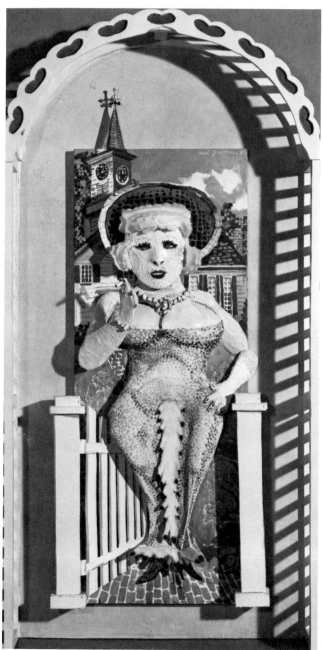

55 *Western Eagle,* 1980
painted bronze
36 x 19 x 32 in.
(91.4 x 48.3 x 81.3 cm.)
Courtesy of Marlborough Gallery,
New York
(Color Plate XIII)

56 *The Living Room,* 1981
oil on canvas
28 x 44 in.
(71.1 x 111.8 cm.)
Lent by the artist

57 *Mae West Visits New England,*
1981
mixed media
45½ x 19 x 7 in.
(115.6 x 48.3 x 17.8 cm.)
Lent by Dr. Jack Chachkes

Nigel Hall
British, born 1943
Currently working in London

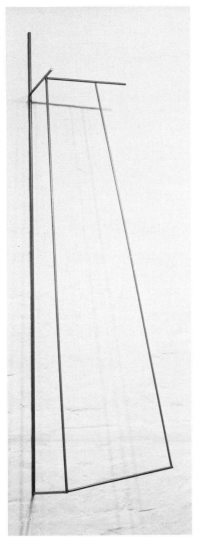

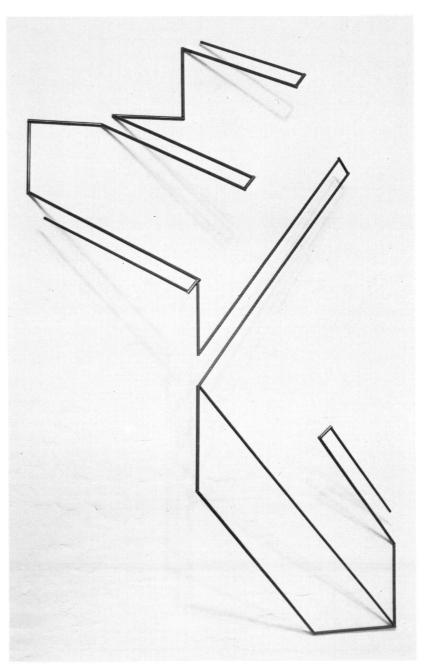

58*

59

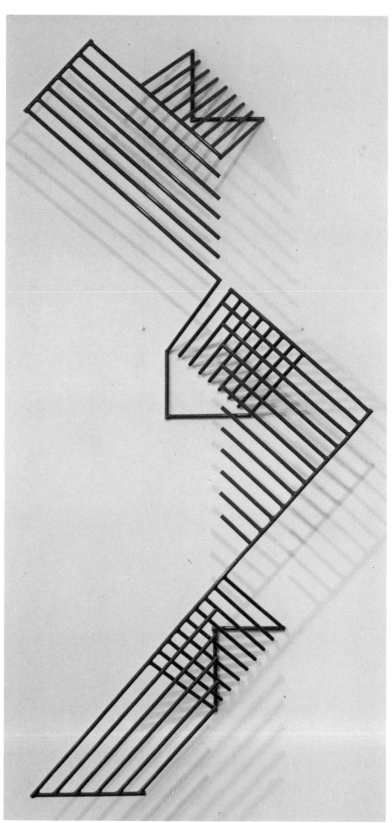

58 *Tautology,* 1979
painted aluminum
$76\frac{9}{16}$ x $18\frac{1}{8}$ x $17\frac{11}{16}$ in.
(194.5 x 46 x 45 cm.)
Courtesy of Juda Rowan Gallery,
London

59 *Spirit of Unnamed Place,* 1981
painted aluminum
$89\frac{3}{16}$ x $57\frac{3}{16}$ x $21\frac{7}{8}$ in.
(226.5 x 145.2 x 55.6 cm.)
Courtesy of Juda Rowan Gallery,
London

60 *Shoal (large),* 1982
painted aluminum
$93\frac{11}{16}$ x $41\frac{15}{16}$ x $10\frac{5}{8}$ in.
(238 x 106.5 x 27 cm.)
Courtesy of Juda Rowan Gallery,
London
(Color Plate XII)

60

Jeffrey Harris
New Zealander, born 1949
Currently working in
Dunedin, New Zealand

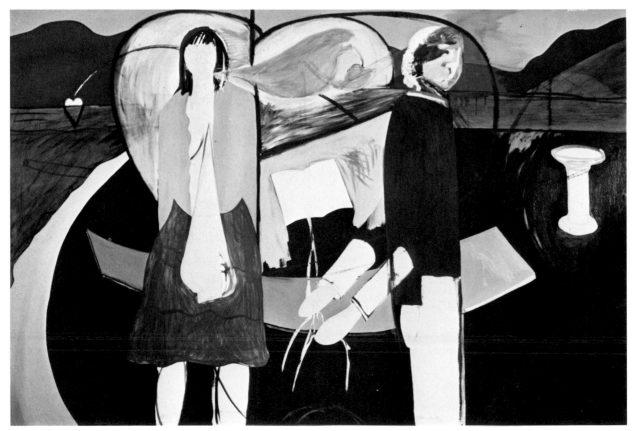

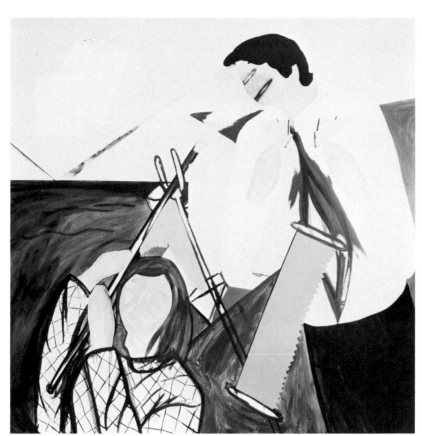

61 *Untitled (Judith) No. 4,* 1978-79
oil on hardboard
47¼ x 70³/₁₆ in.
(120 x 178.2 cm.)
Lent by the artist, courtesy of
Bosshard Galleries, Dunedin,
New Zealand
(Color Plate I)

62 *Untitled,* 1980
oil on hardboard
47⁵/₁₆ x 47⁵/₁₆ in.
(120.2 x 120.2 cm.)
Lent by the artist, courtesy of
Bosshard Galleries, Dunedin,
New Zealand

63 *Untitled (Self-Portrait),* 1980
oil on hardboard
47⁵/₁₆ x 47⅜ in.
(120.2 x 120.3 cm.)
Lent by the artist, courtesy of
Bosshard Galleries, Dunedin,
New Zealand

62*

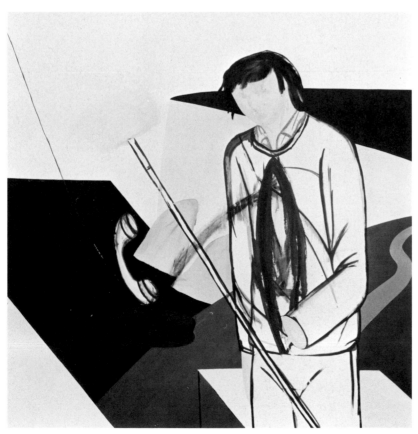

63

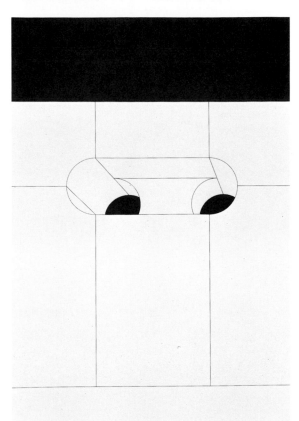

64

Erwin Heerich
German, born 1922
Currently working in Düsseldorf

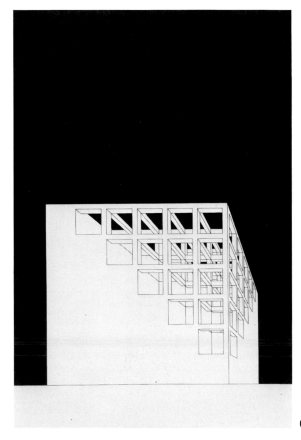

65✱

64 *Untitled,* 1977
cardboard
39⅜ x 25⅝ in.
(100 x 65 cm.)
Courtesy of Galerie Schmela,
Düsseldorf

65 *Untitled,* 1977
cardboard
39⅜ x 25⅝ in.
(100 x 65 cm.)
Courtesy of Galerie Schmela,
Düsseldorf

66 *Untitled,* 1977
cardboard
39⅜ x 25⅝ in.
(100 x 65 cm.)
Courtesy of Galerie Schmela,
Düsseldorf

66

David Hockney
British, born 1937
Currently working in Los Angeles

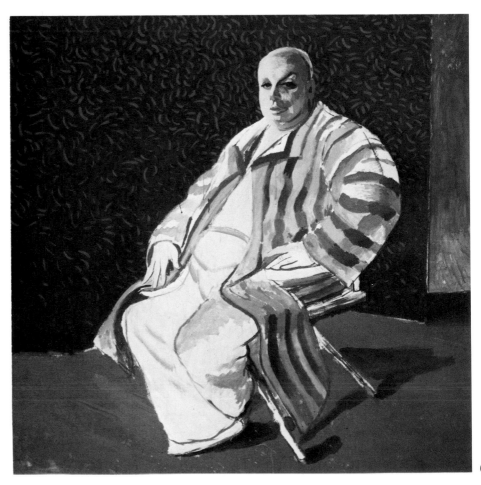

67*

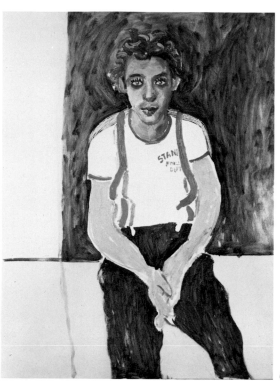

67 *Divine,* 1979
acrylic on canvas
60 x 60 in.
(152.4 x 152.4 cm.)
Lent by the artist

68 *Gregory Evans,* 1980
oil on canvas
48 x 36 in.
(121.9 x 91.4 cm.)
Lent by the artist

69 *Outpost Drive, Hollywood,*
1980-82
acrylic on canvas
60 x 60 in.
(152.4 x 152.4 cm.)
Lent anonymously
(Color Plate XI)

68

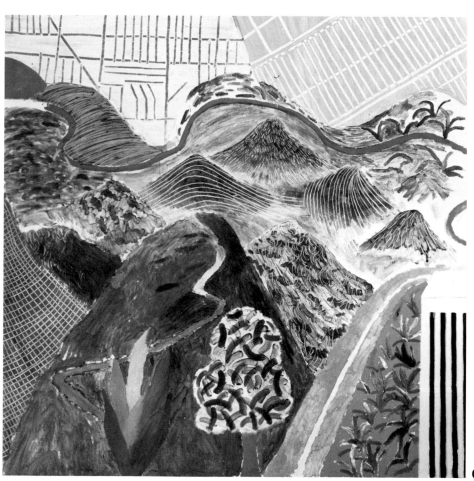

69

John Hoyland
British, born 1934
Currently working in London

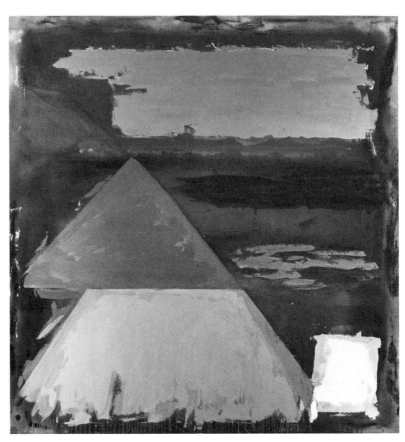

70*

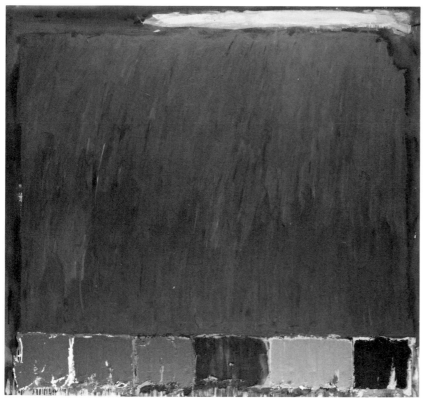

71

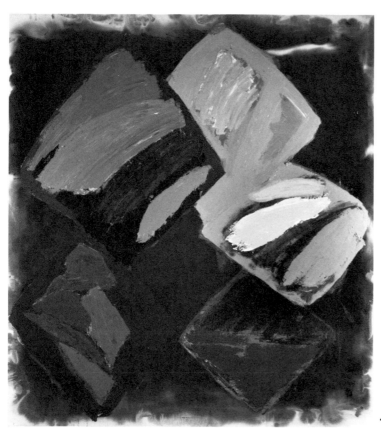

72

70 *Tropicaro 5.11.80,* 1980
acrylic on cotton duck
96 x 90 in.
(243.8 x 228.6 cm.)
Lent by the artist, courtesy of
Waddington Galleries, Ltd.,
London

71 *Pacific 2.29.81,* 1981
acrylic on cotton duck
90 x 96 in.
(228.6 x 243.8 cm.)
Lent by the artist, courtesy of
Waddington Galleries, Ltd.,
London

72 *Hoochy-Coochy,* 1982
acrylic on canvas
100 x 90 in.
(254 x 228.6 cm.)
Courtesy of Jacobson/Hochman
Gallery, New York
(Color Plate III)

73*

José María Iglesias
Spanish, born 1933
Currently working in Madrid

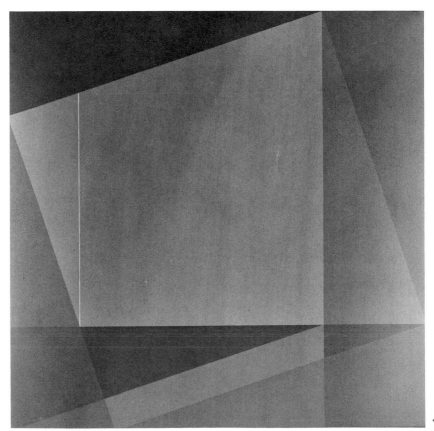

74

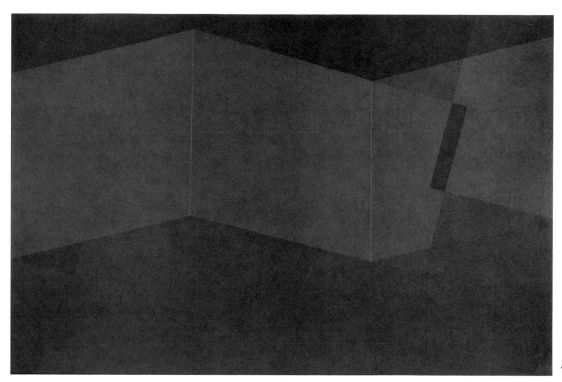

75

73 *Elucidación lúcida para dos
cuadrados iguales en un
rectángulo,* 1980
acrylic on canvas
51³/₁₆ x 76¹³/₁₆ in.
(130 x 195 cm.)
Courtesy of Galería Fernando
Vijande, Madrid

74 *Eldag 22,* 1981
acrylic on canvas
78¾ x 78¾ in.
(200 x 200 cm.)
Courtesy of Galería Fernando
Vijande, Madrid

75 *Eldag 1581,* 1981
acrylic on canvas
51³/₁₆ x 76¹³/₁₆ in.
(130 x 195 cm.)
Courtesy of Galería Fernando
Vijande, Madrid

David Izu
American, born 1951
Currently working in
Oakland, California

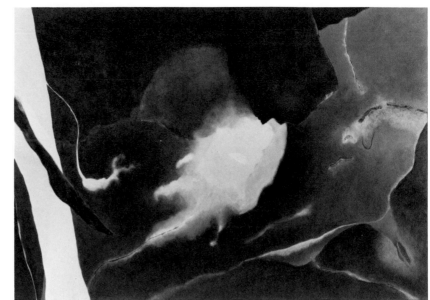

76*

77

76 *Untitled 80.G,* 1980
oil on canvas
59 x 83 in.
(149.9 x 210.8 cm.)
Lent by the artist, courtesy of
William Sawyer Gallery,
San Francisco

77 *Untitled 81.B,* 1981
oil on canvas
59 x 83 in.
(149.9 x 210.8 cm.)
Lent by the artist, courtesy of
William Sawyer Gallery,
San Francisco

78 *Triptych 82.A,* 1982
oil on canvas
triptych, panel I—64 x 36 in.
(162.6 x 91.4 cm.)
panel II—64 x 54 in.
(162.6 x 137.2 cm.)
panel III—64 x 24 in.
(162.6 x 60.7 cm.)
Lent by the artist, courtesy of
William Sawyer Gallery,
San Francisco

78

Patrick Jones
British, born 1948
Currently working in London

79*

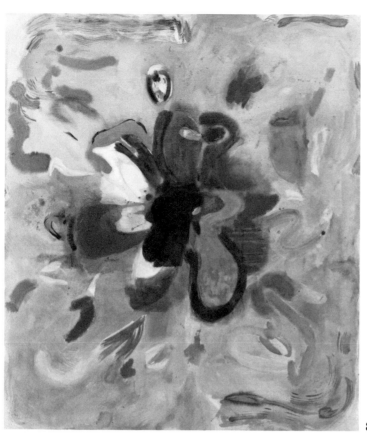

80

79 *Greenwich Painting,* 1980
acrylic and pastel on canvas
68½ x 137½ in.
(174 x 349.3 cm.)
Courtesy of Nicola Jacobs
Gallery, London

80 *Honey B,* 1980
acrylic on canvas
87½ x 74½ in.
(222.3 x 189.2 cm.)
Courtesy of Nicola Jacobs
Gallery, London

81 *Black Painting,* 1982
acrylic on canvas
67 x 137¾ in.
(170.2 x 349.9 cm.)
Courtesy of Nicola Jacobs
Gallery, London

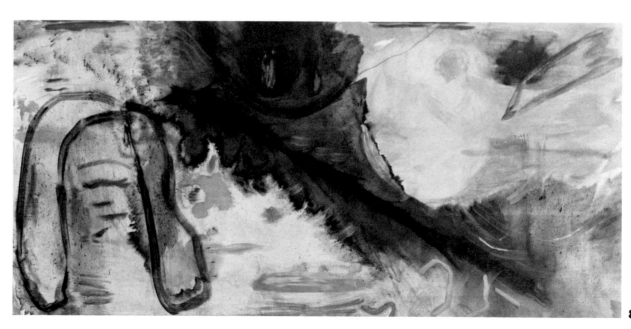

81

Olle Kåks
Swedish, born 1941
Currently working in Stockholm

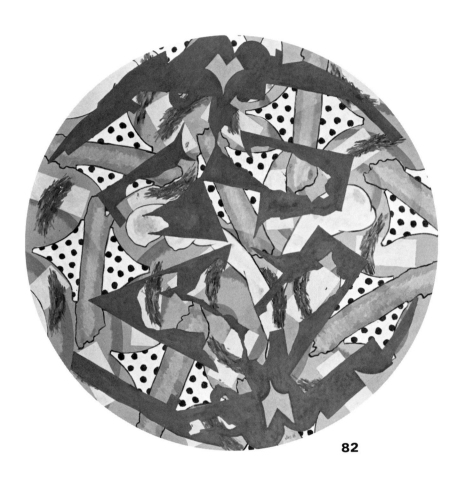

82

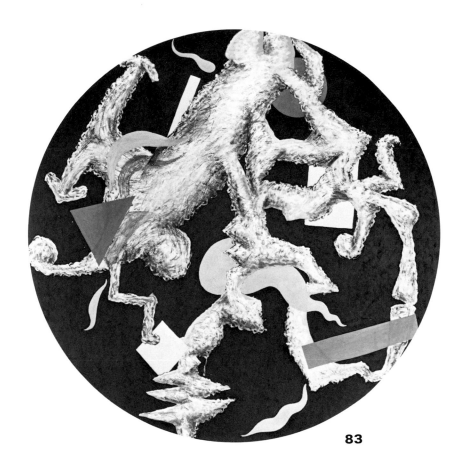

83

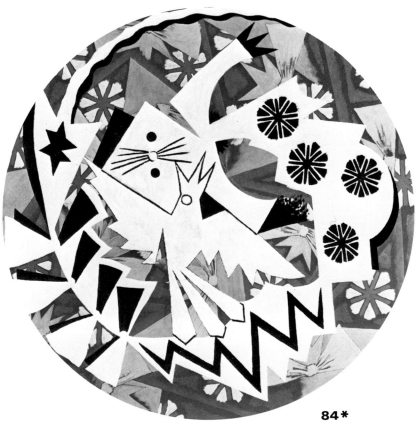

84*

82 *Narcissus,* 1981
oil on linen
Diameter 65 in.
(165 cm.)
Lent by the artist
(Color Plate IV)

83 *Night Emblem,* 1981
oil on linen
Diameter 65 in.
(165 cm.)
Lent by the artist

84 *Spiral—Cat and Bird,* 1981
oil on linen
Diameter 65 in.
(165 cm.)
Lent by the artist

Jin-Suk Kim
Korean, born 1946
Currently working in Seoul

86*

87

85 *The Spront Space-Shadow 798,* 1979
oil on canvas
65 x 52 in.
(165.1 x 132.1 cm.)
Lent by the artist

86 *Yellow Space-Shadow 801,* 1980
oil on canvas
55 x 119 in.
(139.7 x 302.3 cm.)
Lent by the artist

87 *Yellow Space-Shadow 807,* 1980
oil on canvas
65 x 52 in.
(165.1 x 132.1 cm.)
Lent by the artist

Yoshio Kitayama
Japanese, born 1948
Currently working in Kyoto

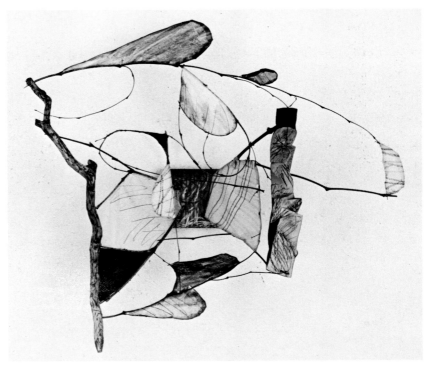

88*

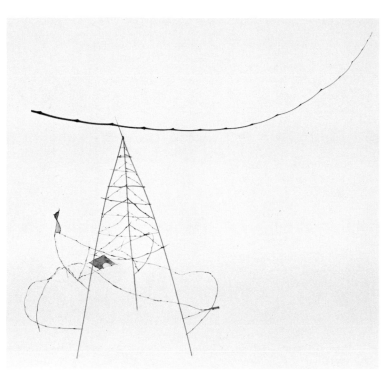

89

88 *Last Hope,* 1981
paper, wood, leather, and copper
25⅝ x 25⅝ x 11 in.
(65 x 65 x 28 cm.)
Courtesy of Galerie 16, Kyoto

89 *A Sign of Sympathy,* 1981
bamboo, paper, and wire
39⅜ x 39⅜ x 37 in.
(100 x 100 x 94 cm.)
Courtesy of Galerie 16, Kyoto

90 *They Are Innocently in the
World Together,* 1981
wood, copper, leather, paper,
and bamboo
54¾ x 68⅛ x 21¹¹/₁₆ in.
(139 x 173 x 55 cm.)
Courtesy of Galerie 16, Kyoto
(Color Plate IX)

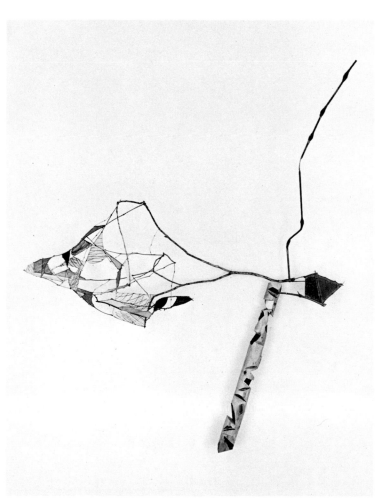

90

Wendy Knox-Leet
Canadian, born 1950
Currently working in New York

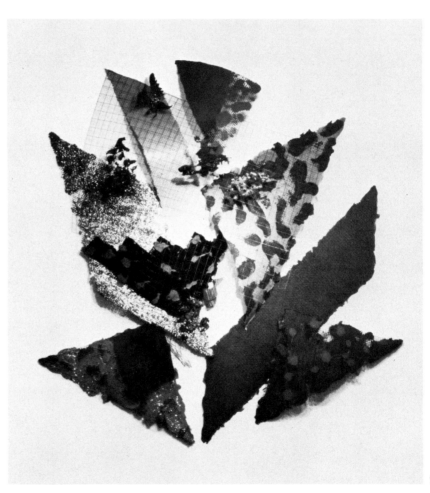

91*

92

93

91 *Curtain Cut,* 1981
wire mesh, sand, acrylic, enamel,
and glitter
120 x 96 x 32 in.
(304.8 x 243.8 x 81.3 cm.)
Courtesy of Gallery Yves Arman,
New York

92 *Fuchsia Spiral,* 1981
wire mesh, acrylic, glitter, plastic
tubing, and coal
84 x 60 x 22 in.
(213.4 x 152.4 x 55.9 cm.)
Courtesy of Gallery Yves Arman,
New York

93 *One-Armed Bandit,* 1981
wire mesh, sheet metal, wood,
acrylic, and enamel
72 x 60 in.
(182.9 x 152.4 cm.)
Courtesy of Gallery Yves Arman,
New York

Lee Krasner
American, born 1908
Currently working in New York

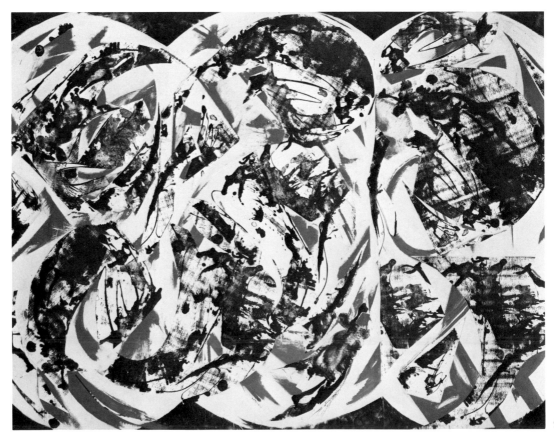

94*

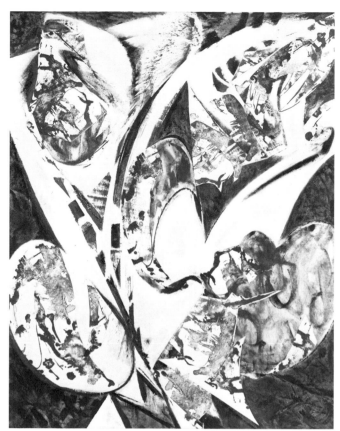

94 *Autumnal Red,* 1980
oil on canvas with paper collage
55¾ x 73 in.
(141.6 x 185.4 cm.)
Courtesy of Robert Miller Gallery,
New York

95 *Crisis Moment,* 1980
oil and paper collage on canvas
69 x 54½ in.
(175.3 x 138.4 cm.)
Courtesy of Robert Miller Gallery,
New York

96 *To the North,* 1980
oil on canvas with collage
58½ x 64 in.
(148.6 x 162.6 cm.)
Courtesy of Robert Miller Gallery,
New York
(Color Plate XIV)

95

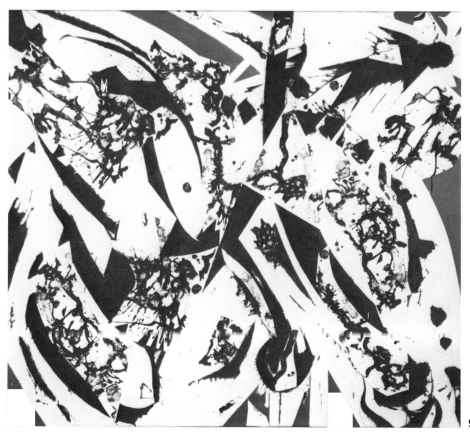

96

Colin Lanceley
New Zealander, born 1938
Currently working in Sydney

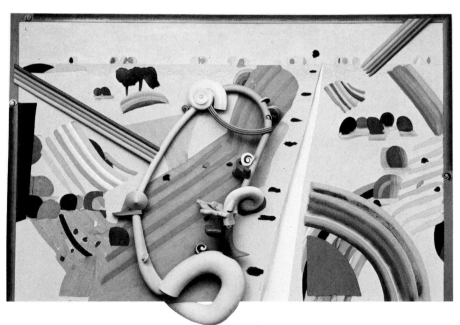

97*

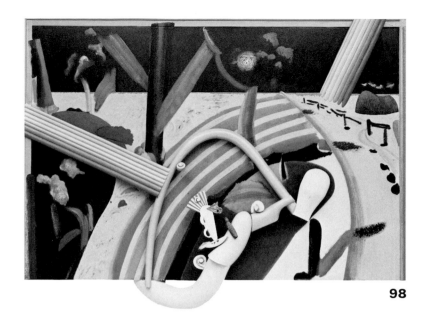

98

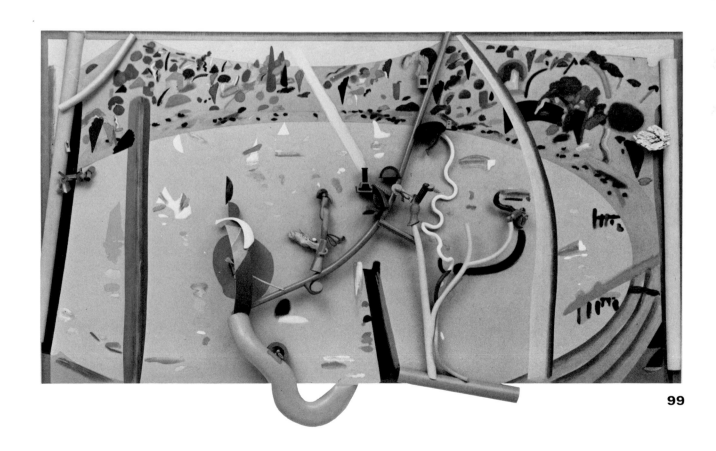

99

Terence La Noue
American, born 1941
Currently working in New York

100*

100 *Zaire,* 1980
acrylic, rhoplex, metallic powder,
and tobacco cloth on canvas
93 x 71 in.
(236.2 x 180.3 cm.)
Courtesy of Nancy Hoffman
Gallery, New York

101 *Maracaibo,* 1981
acrylic, rhoplex, graphite powder,
and tobacco cloth on canvas
94 x 83½ in.
(238.8 x 212.1 cm.)
Courtesy of Nancy Hoffman
Gallery, New York

102 *Patagonia,* 1982
acrylic, rhoplex, and tobacco
cloth on canvas
66 x 67½ in.
(167.6 x 171.5 cm.)
Courtesy of Nancy Hoffman
Gallery, New York

101

102

Jükka Mäkelä
Finnish, born 1949
Currently working in Helsinki

103

103 *In the Morning,* 1981
sand and acrylic on canvas
70⅞ x 70⅞ in.
(180 x 180 cm.)
Lent by the artist

104 *Northern Wind,* 1981
acrylic on canvas
70⅞ x 70⅞ in.
(180 x 180 cm.)
Lent by the artist

105 *Silver Moon,* 1982
sand, aluminum, and acrylic
on canvas
70⅞ x 110¼ in.
(180 x 280 cm.)
Lent by the artist

104*

105

Theodore Manolides
Greek, born 1944
Currently working in Athens

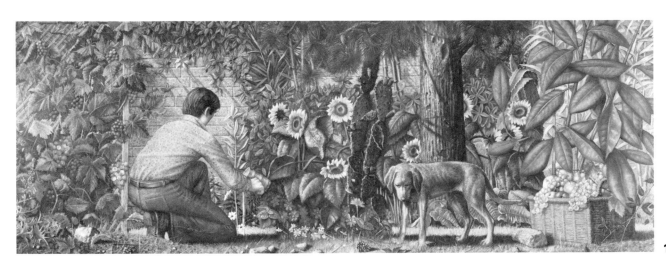

106 *The Garden,* 1980
oil on canvas
43⁵/₁₆ × 118⁵/₁₆ in.
(110 x 300.5 cm.)
Courtesy of Marlborough Gallery,
New York

107 *Still Life in Front of a Screen,*
1981-82
oil on canvas with gold leaf
31½ × 31⅝ in.
(80 x 80.3 cm.)
Courtesy of Marlborough Gallery,
New York

108 *Morning,* 1982
oil on canvas
31⅝ × 27½ in.
(80.3 x 69.9 cm.)
Courtesy of Marlborough Gallery,
New York

107

108*

James McGarrell
American, born 1930
Currently working in
Bloomington, Indiana

109*

110

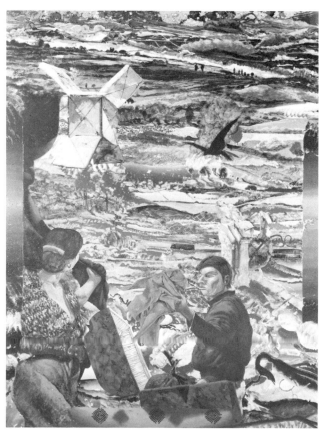

111

109 *Travestimento,* 1980
oil on canvas
92 x 226 in.
(233.7 x 574 cm.)
Courtesy of Allan Frumkin
Gallery, New York

110 *Crossing Move,* 1981-82
oil on canvas
78 x 59 in.
(198.1 x 149.9 cm.)
Courtesy of Allan Frumkin
Gallery, New York
(Color Plate XIX)

111 *Drifting Move,* 1981-82
oil on canvas
78 x 59 in.
(198.1 x 149.9 cm.)
Courtesy of Allan Frumkin
Gallery, New York

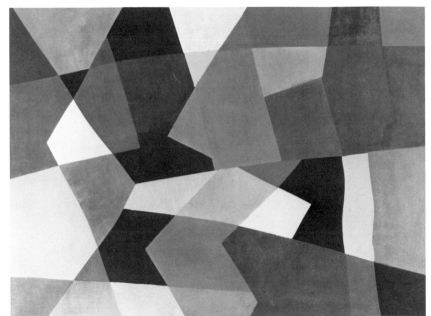

112

Ernst Mether-Borgström
Finnish, born 1917
Currently working in
Espoo, Finland

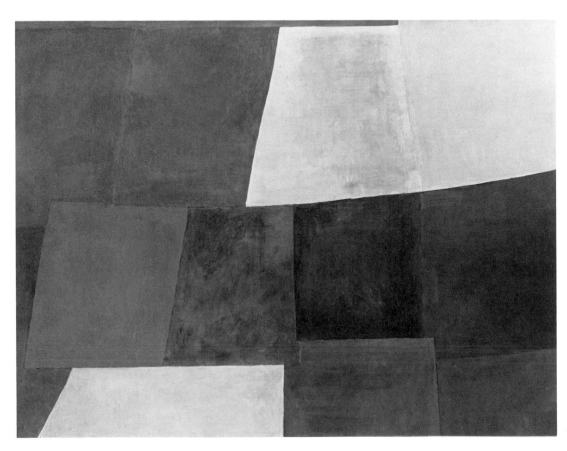

113

112 *Cross Section—I,* 1979
acrylic on canvas
44⅛ x 57½ in.
(112 x 146 cm.)
Lent by the artist

113 *Cross Section—II,* 1982
acrylic on canvas
44⅛ x 57½ in.
(112 x 146 cm.)
Lent by the artist

114 *June,* 1982
acrylic on canvas
44⅛ x 57½ in.
(112 x 146 cm.)
Lent by the artist

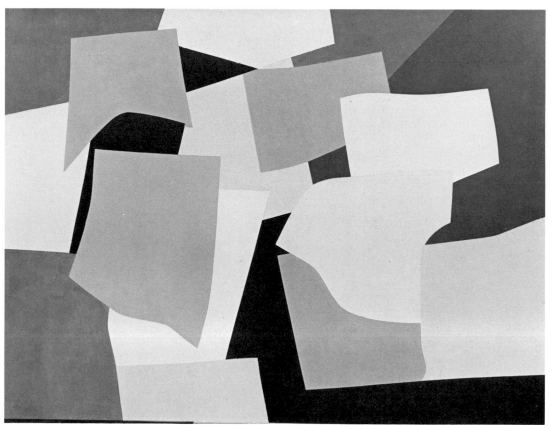

114*

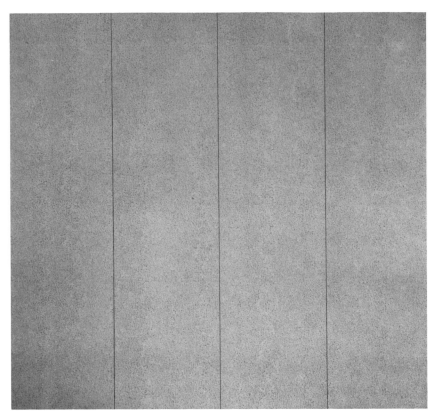

115

Milan Mrkusich
New Zealander, born 1925
Currently working in Auckland

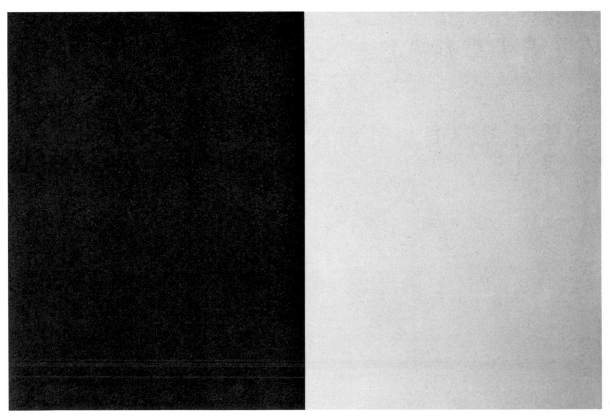

116

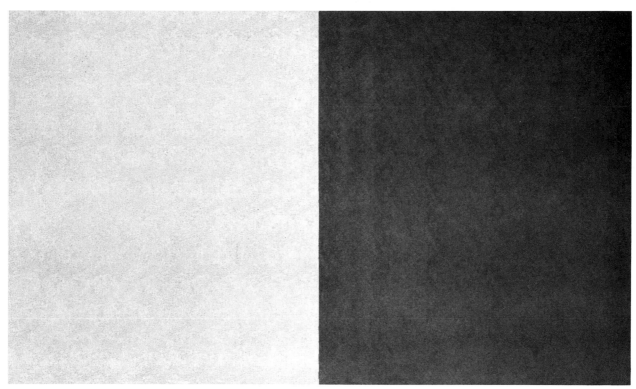

117*

115 *Monochrome Blue, Four Areas,*
 1979
 acrylic on cardboard
 46¾ x 48¼ in.
 (118.7 x 122.5 cm.)
 Lent by the artist, courtesy of
 Bosshard Galleries, Dunedin,
 New Zealand
 (Color Plate II)

116 *Two Areas Orange and Maroon,*
 1980
 acrylic on board
 48¹/₁₆ x 72¹/₁₆ in.
 (122 x 183 cm.)
 Lent by the artist, courtesy of
 Bosshard Galleries, Dunedin,
 New Zealand

117 *Two Areas, Dark,* 1981
 acrylic on board
 47¼ x 79¹⁵/₁₆ in.
 (120 x 203 cm.)
 Lent by the artist, courtesy of
 Bosshard Galleries, Dunedin,
 New Zealand

Pierre Nivollet
French, born 1946
Currently working in Paris

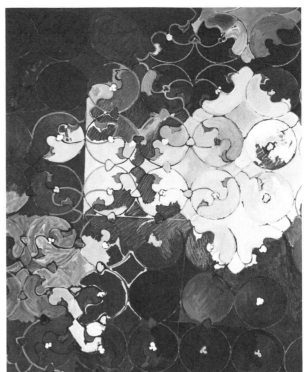

118

119

118 *Arabesque,* 1980
oil on canvas
63 x 51³⁄₁₆ in.
(160 x 130 cm.)
Lent by the artist

119 *Image du Monde,* 1981
oil on canvas
82¹¹⁄₁₆ x 70⅞ in.
(210 x 180 cm.)
Lent by the artist

120 *Image du Monde,* 1982
oil on canvas
82¹¹⁄₁₆ x 70⅞ in.
(210 x 180 cm.)
Lent by the artist

120*

Felipe Carlos Pino
Argentinian, born 1945
Currently working in
Buenos Aires

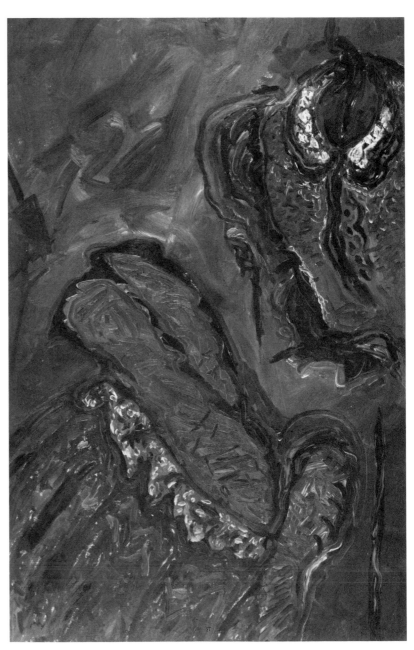

121 *Untitled,* 1979
oil on canvas
55⅛ x 35⁷/₁₆ in.
(140 x 90 cm.)
Lent by the artist, courtesy of
Daniel Levinas

122 *Untitled,* 1980
oil on canvas
55⅛ x 35⁷/₁₆ in.
(140 x 90 cm.)
Lent by the artist, courtesy of
Daniel Levinas

123 *Untitled,* 1981
oil and collage on board
39⅜ x 27⁹/₁₆ in.
(100 x 70 cm.)
Lent by the artist, courtesy of
Daniel Levinas
(not illustrated)

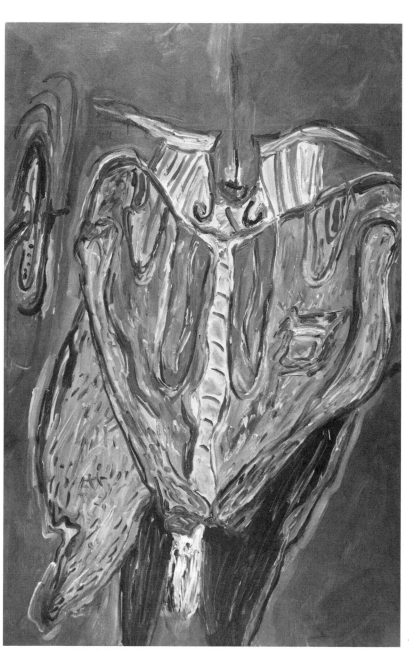

122

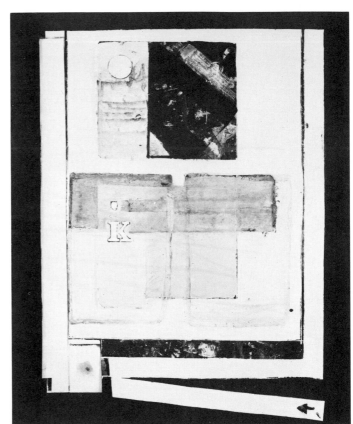

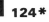

124*

Fernando García Ponce
Mexican, born 1933
Currently working in Mexico City

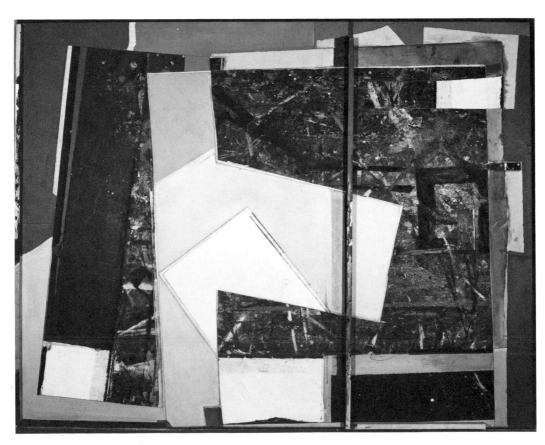

125

124 *Untitled,* 1980
mixed media
68⅞ x 59¹/₁₆ in.
(175 x 150 cm.)
Courtesy of Galería Ponce,
Mexico City

125 *Untitled,* 1980
mixed media on wood
65 x 83¹/₁₆ in.
(165 x 211 cm.)
Courtesy of Galería Ponce,
Mexico City

126 *Triangle over Black and
Red Composition,* 1982
mixed media
63 x 63 in.
(160 x 160 cm.)
Courtesy of Galería Ponce,
Mexico City

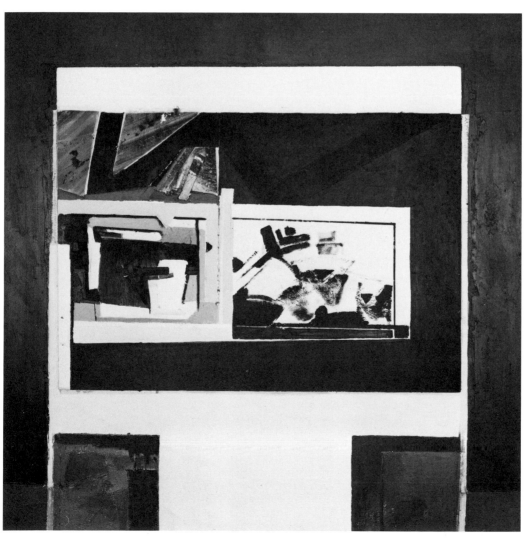

126

Karl Prantl
Austrian, born 1923
Currently working in
Pöttsching, Austria

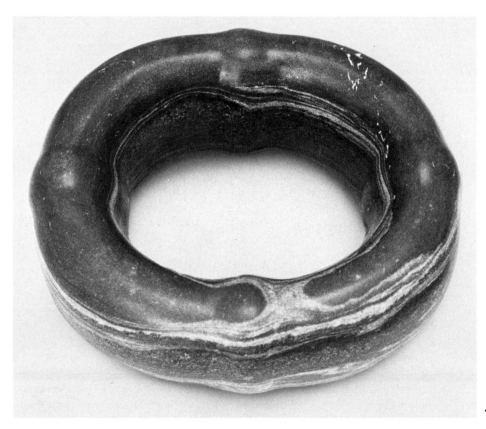

127 *Ring,* 1979
Mühldorf marble
10¼ x 23⅝ x 20½ in.
(26 x 60 x 52 cm.)
Lent by the artist

128 *Zur Meditation,* 1980
black Swedish granite
4¾ x 24⅝ x 39⅜ in.
(12 x 62.5 x 100 cm.)
Lent by the artist

129 *Stein zur Meditation,* 1981
amazonite
7⅞ x 86¼ x 19¹¹/₁₆ in.
(20 x 219 x 50 cm.)
Lent by the artist

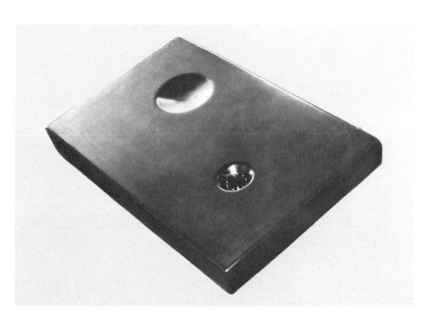

128*

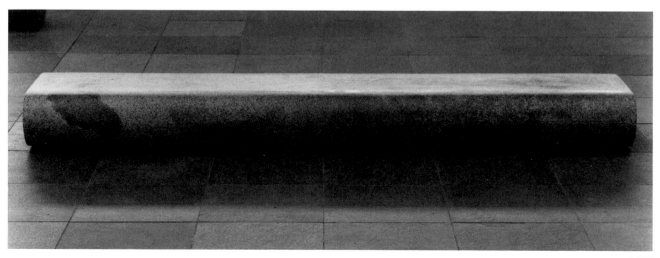

129

Jan Riske
Dutch, born 1932
Currently working in Sydney

130

131*

132

130 *Grey Vibrations,* 1980
oil on canvas
49¹³/₁₆ x 49¹³/₁₆ in.
(125 x 125 cm.)
Courtesy of Art of Man Gallery,
Paddington, Australia

131 *Light Transfer,* 1981
oil on canvas
74¹³/₁₆ x 82¹¹/₁₆ in.
(190 x 210 cm.)
Courtesy of Art of Man Gallery,
Paddington, Australia

132 *Light,* 1982
oil on canvas
19¹¹/₁₆ x 19¹¹/₁₆ in.
(50 x 50 cm.)
Courtesy of Art of Man Gallery,
Paddington, Australia

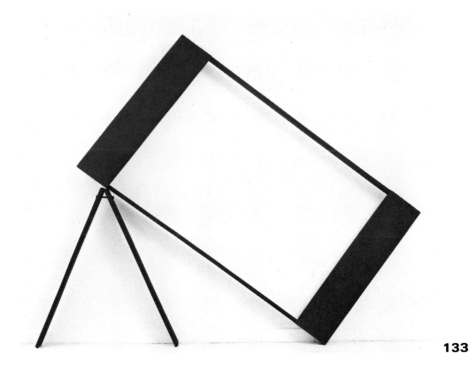

133

Yoshishige Saito
Japanese, born 1904
Currently working in Tokyo

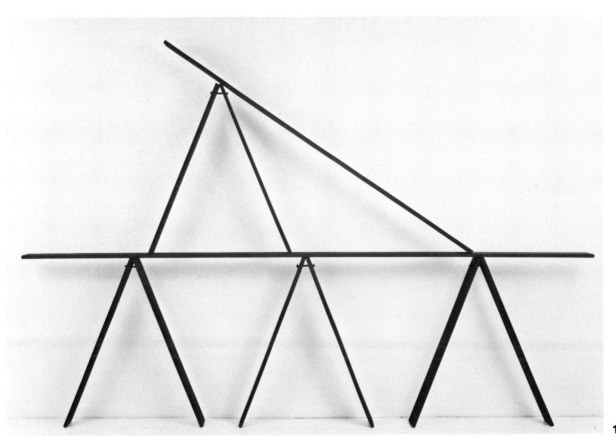

134

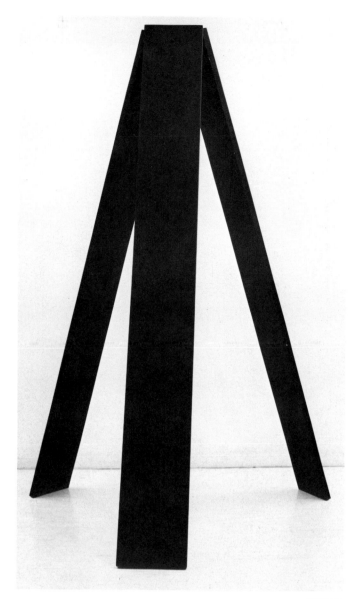

135*

133 *Disproportion #1,* 1980
wood
73¼ x 86¼ x 4¾ in.
(186 x 219 x 12 cm.)
Courtesy of Tokyo Gallery, Tokyo

134 *Disproportion #9,* 1980
wood
86⅝ x 129¹⁵/₁₆ x 5¹⁵/₁₆ in.
(220 x 330 x 15 cm.)
Courtesy of Tokyo Gallery, Tokyo

135 *Disproportion #12,* 1982
wood
98⁷/₁₆ x 66⅛ x 54¹/₁₆ in.
(250 x 168 x 138 cm.)
Courtesy of Tokyo Gallery, Tokyo

Miloš Sarić
Yugoslavian, born 1927
Currently working in Belgrade

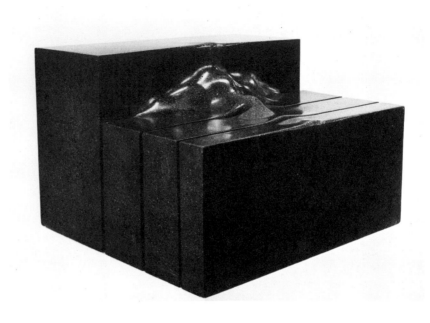

136

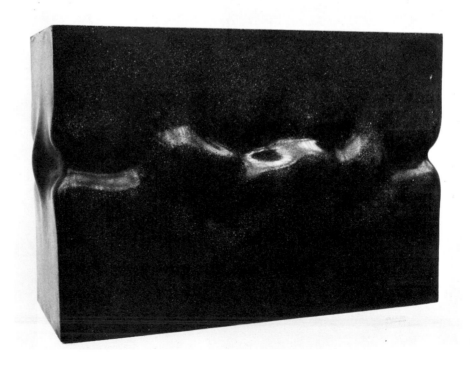

137*

136 *Blok XL,* 1979
polyester marble
15⅜ x 17¾ x 11 in.
(39 x 45 x 28 cm.)
Lent by the artist

137 *Blok XLIX,* 1979
polyester marble
17¾ x 26 x 11 in.
(45 x 66 x 28 cm.)
Lent by the artist

138 *Interaction III,* 1982
polyester marble
27⁹/₁₆ x 39¾ x 16¹⁵/₁₆ in.
(70 x 101 x 43 cm.)
Lent by the artist

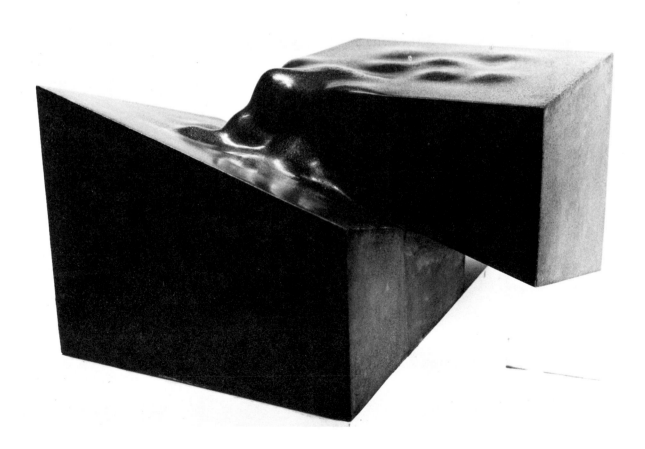

139

David Schirm
American, born 1945
Currently working in Los Angeles

140

139 *All the Glad Variety,* 1980
acrylic, Prismacolor, and
collage on canvas
72 x 72¼ in.
(182.9 x 183.5 cm.)
Courtesy of Siegel
Contemporary Art, New York

140 *Painting Breathes
on the Night,* 1980
acrylic, Prismacolor, and
collage on canvas
60½ x 132½ in.
(153.7 x 336.6 cm.)
Courtesy of Michael Berger
Gallery, Pittsburgh, and
Siegel Contemporary Art,
New York

141 *Hybrid Vigor Meets the
Black Hole,* 1981
acrylic, Prismacolor, and
collage on canvas
66⅝ x 132⅞ in.
(169.2 x 336.9 cm.)
Courtesy of Siegel
Contemporary Art,
New York, and Tortue Gallery,
Santa Monica

141*

Buky Schwartz
Israeli, born 1932
Currently working in New York
and Tel Aviv

142

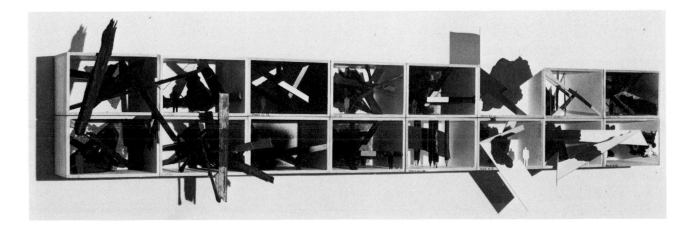

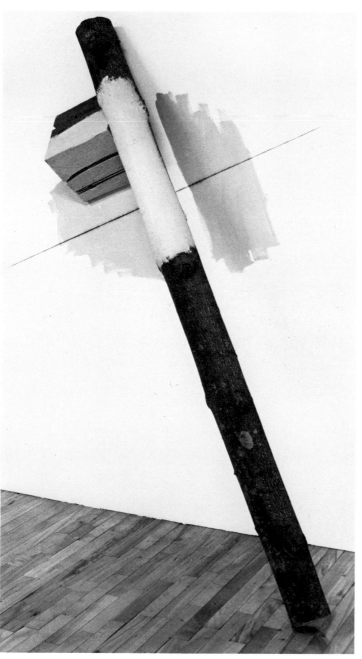

142 *Interiors,* 1982
wood, concrete, mirror, branch,
and acrylic
14 x 47 x 18 in.
(35.6 x 119.4 x 45.7 cm.)
Lent by the artist

143 *Sixteen Boxes,* 1982
wood, cardboard, mirror, glass,
and acrylic
14 x 47 x 5 in.
(35.6 x 119.4 x 12.7 cm.)
Lent by the artist

144 *Yellow Splash,* 1982
wood, acrylic, and
powder pigment
79 x 60 x 30 in.
(200.7 x 152.4 x 76.2 cm.)
Lent by the artist

144

Michael Shannon
Australian, born 1927
Currently working in Melbourne

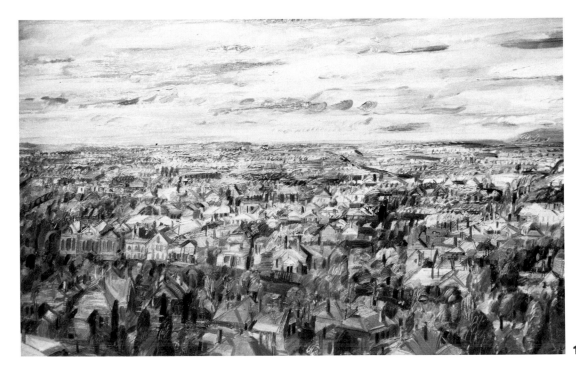

145

145 *Suburban Landscape—*
Melbourne, 1979
oil on canvas
47⅞ x 78 in.
(121.5 x 198 cm.)
Lent by the artist, courtesy of
Powell Street Gallery, Melbourne

146 *Yarra from Johnston*
Street Bridge, 1979
oil on canvas
36 x 72 in.
(91.5 x 183 cm.)
Lent by the artist, courtesy of
Powell Street Gallery, Melbourne
(Color Plate V)

＊147 *Hillside with Trees,* 1982
oil on canvas
39⅜ x 78¾ in.
(100 x 200 cm.)
Lent by the artist, courtesy of
Powell Street Gallery, Melbourne
(not illustrated)

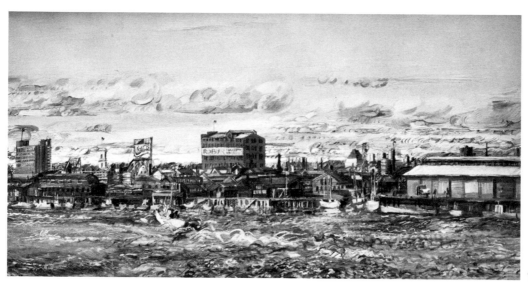

146

Susana Sierra
Mexican, born 1942
Currently working in Mexico City

148

148 *De Entre Los Sueños,* 1980
mixed media on canvas
98⁷/₁₆ 78¾ in.
(250 x 200 cm.)
Courtesy of Galería Juan Martín,
Mexico City

149 *Viaje Interior,* 1980
mixed media on canvas
63 x 55⅛ in.
(160 x 140 cm.)
Courtesy of Galería Juan Martín,
Mexico City

150 *El Alma de La Noche,* 1981
mixed media on canvas
39⅜ x 47¼ in.
(100 x 120 cm.)
Courtesy of Galería Juan Martín,
Mexico City

149✳

150

151

Judy Singer
Canadian, born 1951
Currently working in Toronto

152*

153

151 *Affection,* 1981
acrylic on canvas
71 x 47½ in.
(180.3 x 120.7 cm.)
Lent by H. J. Heinz Company,
Pittsburgh
(Color Plate XVII)

152 *Brava,* 1982
acrylic on canvas
48 x 84 in.
(121.9 x 213.4 cm.)
Lent by the artist

153 *Summertime,* 1982
acrylic on canvas
78 x 44 in.
(198.1 x 111.8 cm.)
Lent by the artist

Adir Sodré de Sousa
Brazilian, born 1962
Currently working in
Cuiaba, Brazil

154*

154 *Enterro de anjo,* 1979
oil on canvas
51³/₁₆ x 66¹⁵/₁₆ in.
(130 x 170 cm.)
Lent by the artist

155 *Salao de barbeiro,* 1979
oil on canvas
29⅛ x 36¼ in.
(74 x 92 cm.)
Lent by the artist

156 *TViolencia,* 1980
oil on canvas
29½ x 39⅜ in.
(75 x 100 cm.)
Lent by the artist

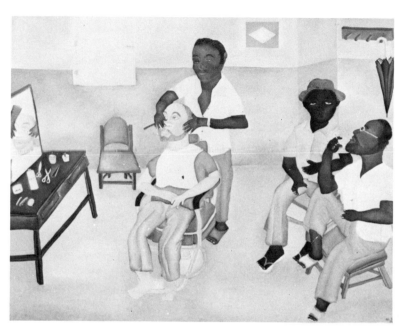

155

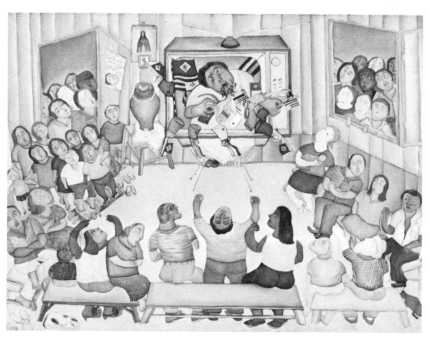

156

Albert Stadler
American, born 1923
Currently working in New York

157

158*

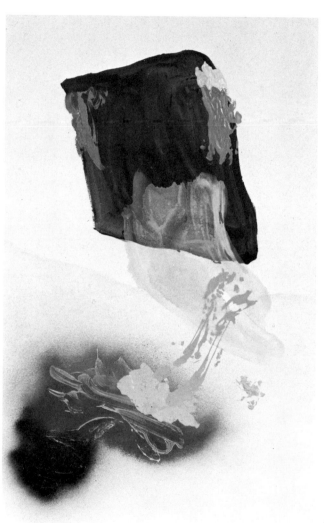

159

157 *Arcing Light,* 1981
acrylic on canvas
79½ x 170½ in.
(201.9 x 433.1 cm.)
Museum of Art, Carnegie Institute;
The Henry L. Hillman
Purchase Fund 81.29.2
(Color Plate XVIII)

158 *Landfall,* 1981
acrylic on canvas
43 x 196 in.
(109.2 x 497.8 cm.)
Lent by the artist

159 *Pheromone,* 1981
acrylic on canvas
69 x 42 in.
(175.3 x 106.7 cm.)
Lent by the artist

David Stoltz
American, born 1943
Currently working in New York

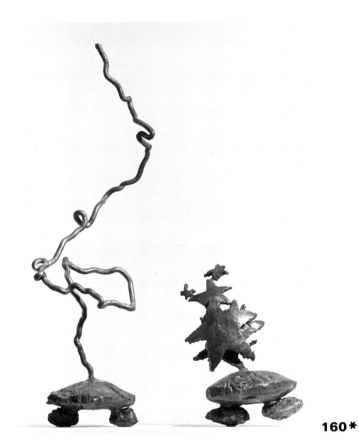

160*

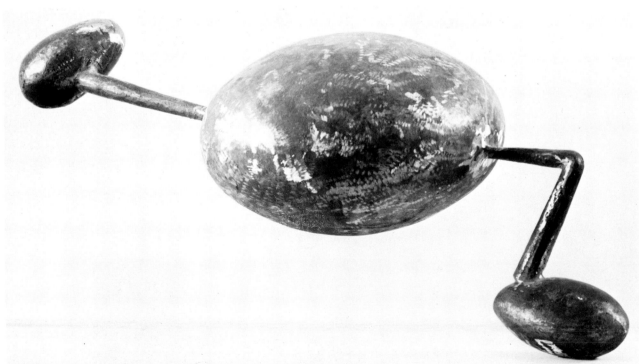

161

160 *Starburst,* 1981
steel
17 x 6 x 12 in.
(43.2 x 15.2 x 30.5 cm.)
Lent by the artist

161 *Stepping Out,* 1981
steel
17 x 40 x 17 in.
(43.2 x 101.6 x 43.2 cm.)
Lent by Sibylle Gaussen

162 *Utica II,* 1981
painted steel
168 x 360 x 240 in.
(426.7 x 914.4 x 609.6 cm.)
Lent by the artist

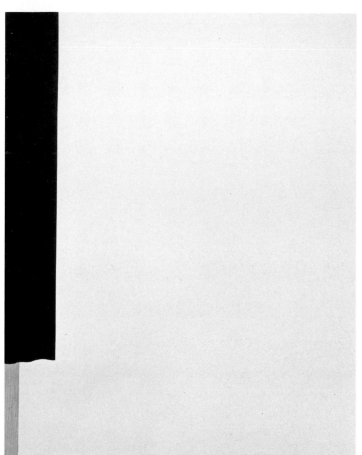

163

Kishio Suga
Japanese, born 1944
Currently working in Tokyo

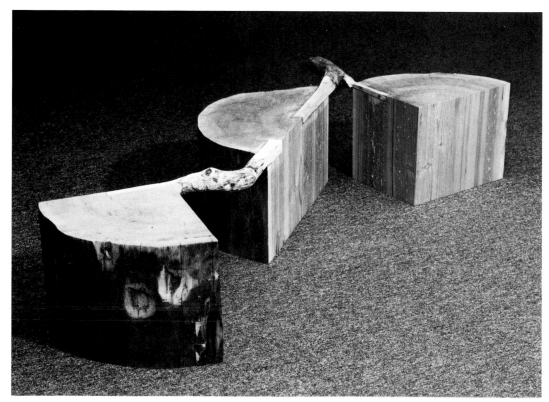

164

163 *Profusion,* 1980
wood panel and canvas
59⅞ x 47⅝ x 2⅜ in.
(152 x 121 x 6 cm.)
Courtesy of Tokyo Gallery, Tokyo

164 *Joint,* 1981
wood
28⅜ x 61 x 13⅜ in.
(72 x 155 x 34 cm.)
Courtesy of Tokyo Gallery, Tokyo

165 *Protrusion 381, 382, 383,* 1981
wood panel and canvas
triptych, 47¼ x 141¾ x 2½ in.
(120 x 360 x 6.3 cm.) overall
Lent by The Metropolitan
Museum, Tokyo

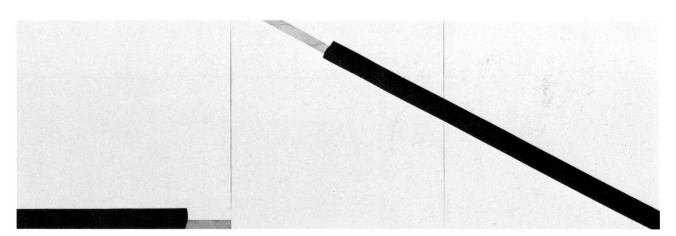

165*

Antoni Tàpies
Spanish, born 1923
Currently working in Barcelona

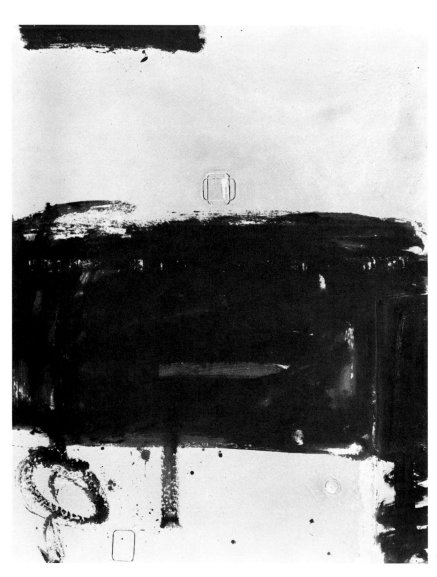

166*

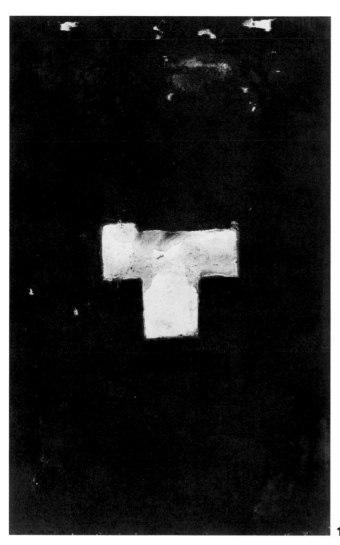

166 *Black over Grey Material,* 1980
mixed media on wood
57½ x 44⅞ in.
(146.1 x 114 cm.)
Lent by the artist, courtesy of
M. Knoedler & Co., Inc., New York

167 *White T,* 1980
mixed media on wood
51³/₁₆ x 31⅞ in.
(130 x 81 cm.)
Lent by the artist, courtesy of
M. Knoedler & Co., Inc., New York

168 *Inclined Ochre,* 1981
mixed media on wood
35 x 45¹¹/₁₆ in.
(88.9 x 116 cm.)
Lent by the artist, courtesy of
M. Knoedler & Co., Inc., New York

167

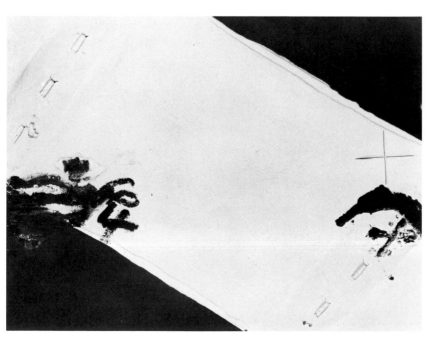

168

Kakuzo Tatehata
Japanese, born 1919
Currently working in Tokyo

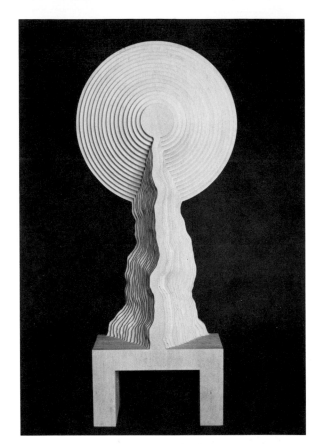

169

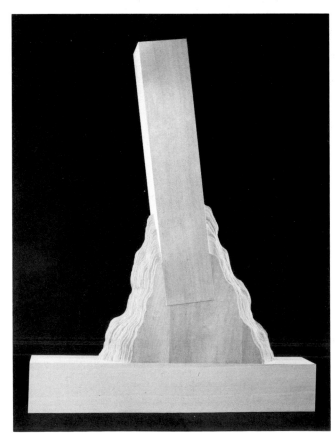

170

169 *Cloud 17,* 1981
wood
63⅜ x 28 x 11 in.
(161 x 71 x 28 cm.)
Lent by the artist

170 *Cloud 4,* 1982
wood
51³/₁₆ x 39⅜ x 6¹¹/₁₆ in.
(130 x 100 x 17 cm.)
Lent by the artist

171 *Cloud 19,* 1982
wood
76⅜ x 47⅝ x 31⅞ in.
(194 x 121 x 81 cm.)
Lent by the artist

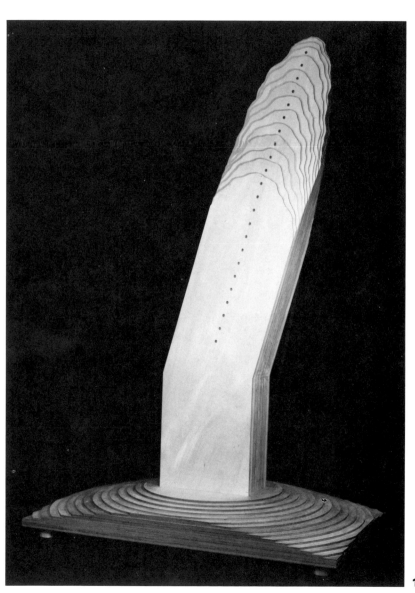

171*

Greer Twiss
New Zealander, born 1937
Currently working in Auckland

172*

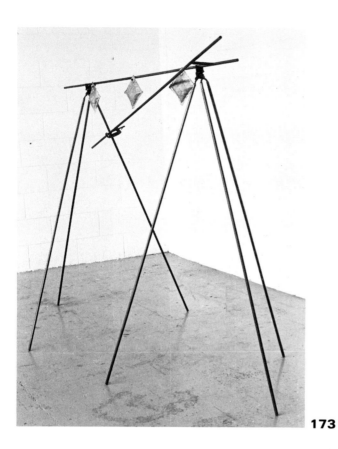

173

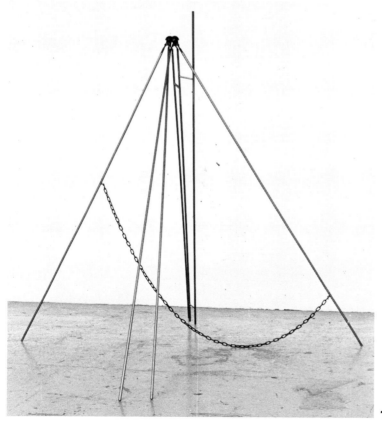

174

172 *Support System II,* 1979
steel and aluminum
63¾ x 208¼ x 43⁵⁄₁₆ in.
(162 x 529 x 110 cm.)
Lent by the artist

173 *Sandbags,* 1981
steel and aluminum
59¹⁄₁₆ x 118⅛ x 39⅜ in.
(150 x 300 x 100 cm.)
Lent by the artist

174 *Hemispheres,* 1982
steel and bronze
78¾ x 118⅛ x 118⅛ in.
(200 x 300 x 300 cm.)
Lent by the artist

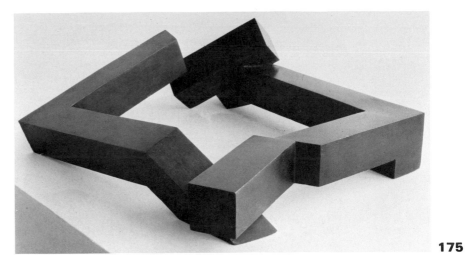

175

Michael Warren
Irish, born 1950
Currently working in
Gorey, County Wexford

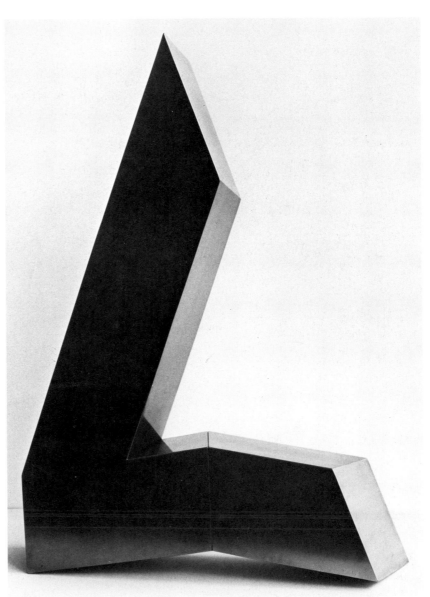

176*

175 *Dark Night,* 1979-80
bronze
5$^{15}/_{16}$ x 15$^3/_4$ x 15$^3/_4$ in.
(15 x 40 x 40 cm.)
Lent by the artist

176 *Pyramid,* 1982
stainless steel
38$^3/_4$ x 27$^9/_{16}$ x 7$^1/_2$ in.
(98.5 x 70 x 19 cm.)
Lent by the artist

177 *Triptychos I,* 1982
oak
61 x 63 x 21$^1/_4$ in.
(155 x 160 x 54 cm.)
Lent by the artist

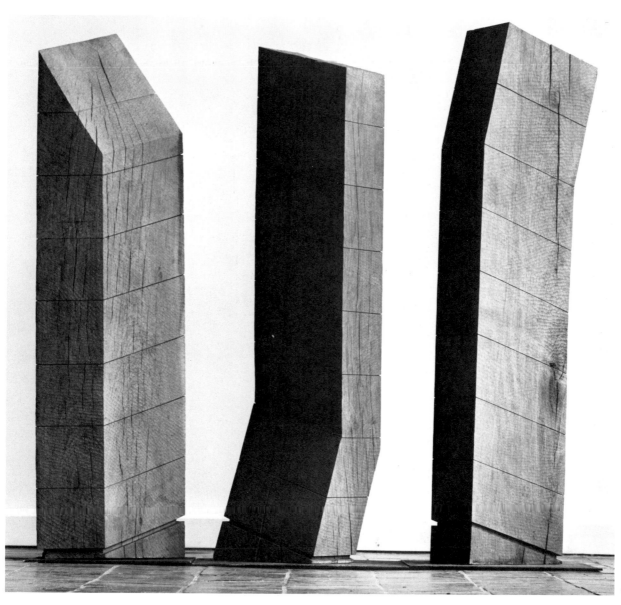

177

Jakob Weidemann
Norwegian, born 1923
Currently working in
Lillehammer, Norway

178 *Untitled No. 14* from
"Impressions from Nature,"
1981-82
oil on canvas
70⅞ x 78¾ in.
(180 x 200 cm.)
Lent by Henie-Onstad
Foundation, Høvikodden, Norway

179 *Untitled No. 22* from
"Impressions from Nature,"
1981-82
oil on canvas
47¼ x 47¼ in.
(120 x 120 cm.)
Lent by the artist

180 *Untitled No. 33* from
"Impressions from Nature,"
1982
oil on canvas
78¾ x 98⁷⁄₁₆ in.
(200 x 250 cm.)
Lent by Nasjonalgalleriet, Oslo

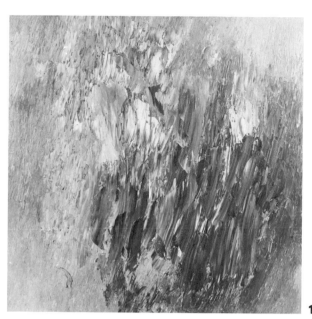

179

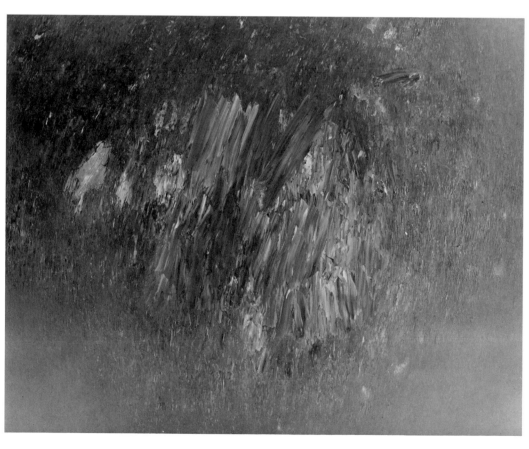

180*

Christopher Wilmarth
American, born 1943
Currently working in New York

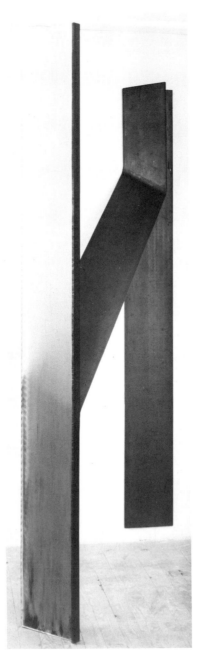

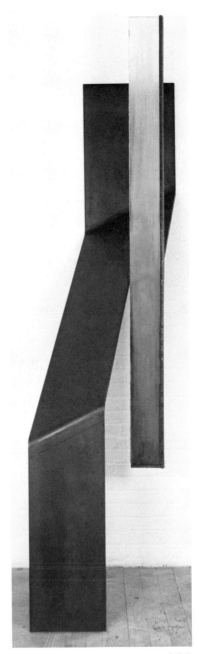

181* 182

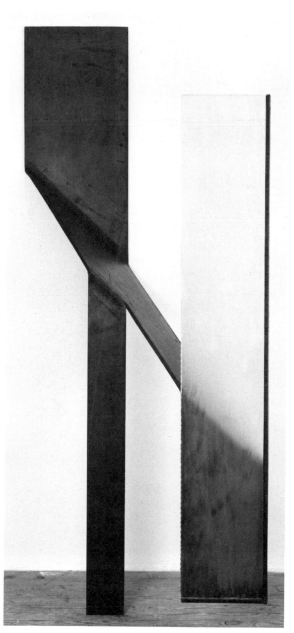

183

Isaac Witkin
American, born South Africa,
1936
Currently working in
Hopewell, New Jersey

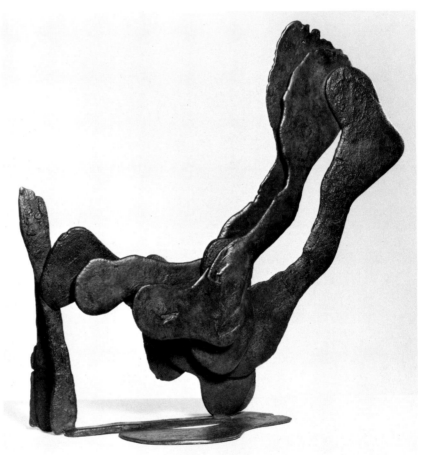

184*

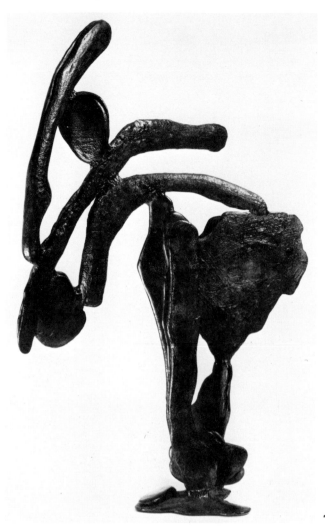

184 *Diver,* 1981
bronze
38½ x 39½ x 14½ in.
(97.8 x 100.3 x 36.8 cm.)
Lent by the artist

185 *Crazy Horse,* 1982
bronze
47½ x 32 x 17½ in.
(120.7 x 81.3 x 44.5 cm.)
Lent by the artist

186 *Linden Tree,* 1982
bronze
25½ x 16½ x 12 in.
(64.8 x 41.9 x 30.5 cm.)
Lent by the artist

185

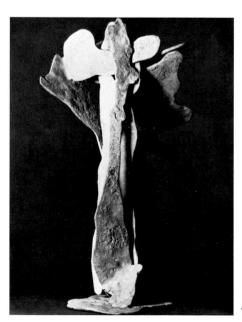

186

Sanford Wurmfeld
American, born 1942
Currently working in New York

187*

188

189

187 *II-29 (N) #1,* 1981
acrylic on canvas
85½ x 85½ in.
(217.2 x 217.2 cm.)
Lent by The Metropolitan
Museum of Art, New York,
Edith C. Blum Fund, 1982

188 *II-29 (LN) #1,* 1982
acrylic on canvas
85½ x 85½ in.
(217.2 x 217.2 cm.)
Lent by the artist

189 *II-39 (12H, 5V, 35) Dark BV—*
Light YO #1, 1982
acrylic on canvas
85½ x 85½ in.
(217.2 x 217.2 cm.)
Lent by the artist

Lenders to the Exhibition

Anonymous (2)
Allan Frumkin Gallery, New York
Ilona Anderson
André Emmerich Gallery, New York
Art of Man Gallery, Paddington, Australia
Arte Nuevo, Galería de Arte, Buenos Aires
Antonio Sergio Benevento
Max Bill
Bosshard Galleries, Dunedin, New Zealand
Dr. Jack Chachkes
Collection d'Art/galerie, Amsterdam
Jorge Demirjián
Piero Dorazio
Galería Fernando Vijande, Madrid
Galería Juan Martín, Mexico City
Galería Ponce, Mexico City
Galerie Jean Fournier, Paris
Galerie Schmela, Düsseldorf
Galerie 16, Kyoto
Galerie Suzanne Fischer, Baden-Baden
Gallery Yves Arman, New York
Sibylle Gaussen
Johannes Geccelli
Gotthard Graubner
Red Grooms
H. J. Heinz Company, Pittsburgh
Jeffrey Harris
Henie-Onstad Foundations, Høvikodden, Norway
Hirschl and Adler Modern, New York
David Hockney
John Hoyland
David Izu
Jacobson/Hochman Gallery, New York
Juda Rowan Gallery, London
Olle Kåks
Jin-Suk Kim
Daniel Levinas
m Bochum, Bochum, West Germany
M. Knoedler & Company, Inc., New York
Macquarie Galleries, Sydney
Jukka Mäkelä
Marlborough Gallery, New York
Ernst Mether-Borgström
The Metropolitan Museum, Tokyo
The Metropolitan Museum of Art, New York
Michael Berger Gallery, Pittsburgh
Milan Mrkusich
Museum of Art, Carnegie Institute, Pittsburgh
Nancy Hoffman Gallery, New York
Nasjonalgalleriet, Oslo
Nicola Jacobs Gallery, London
Pierre Nivollet
The Pace Gallery, New York
Felipe Carlos Pino
Powell Street Gallery, Melbourne
Karl Prantl
Richard Gray Gallery, Chicago
Robert Miller Gallery, New York
Milŏs Sarić

Buky Schwartz
Michael Shannon
Siegel Contemporary Art, New York
Judy Singer
Adir Sodré de Sousa
Albert Stadler
David Stoltz
Studio for the First Amendment, New York
Antoni Tàpies
Kakuzo Tatehata
Tokyo Gallery, Tokyo
Tortue Gallery, Santa Monica, California
Greer Twiss
Waddington Galleries, Ltd., London
Michael Warren
Jakob Weidemann
Isaac Witkin
William Sawyer Gallery, San Francisco
Sanford Wurmfeld

Photographic Credits:

Catalogue numbers 109, 110, 111, Allan Frumkin Gallery. 31, 33, Arte Nuevo. 79, 80, 81, Jonathan Bayer. 61, 62, 63, Bosshard Galleries. 9, Fons Brasser. 37, Bob Brooks. 27, 121, 122, 123, 157, Kevin Brunelle. 160, Charles Cowles Gallery. 129, Eva Choung-Fux. 166, 167, 168, Ken Cohen for M. Knoedler & Co., Inc. 7, 8, 9, Collection d'Art. 130, 131, 132, Jill Crossley. 100, Bevan Davis for Nancy Hoffman Gallery. 139, 140, 141, D. James Dee for Siegel Contemporary Art. 176, 177, John Donat. 94, 95, 109, 110, 111, 161, 162, Eeva-Inkeri. 76, 77, 78, M. Lee Fatherree. 82, 83, 84, Fotografen i Fagersta. 124, 125, 126, Galería Ponce. 52, Galerie M. 152, 153, Galerie One. 64, 65, 66, Galerie Schmela. 85, 86, 87, Galerie 16. 128, Robert Häusser. 37, 38, 39, Hirschl and Adler Galleries. 16, 17, 18, Jacqueline Hyde. 72, Jacobson/Hochman Gallery. 178, 179, Karl Johansgt. 58, 59, 60, Juda Rowan Gallery. 88, 89, 90, Hiroshi Kimura. 97, 98, 99, Macquarie Galleries. 19, 21, 22, 23, 24, 55, 106, 107, 108, Marlborough Gallery. 20, 21, Robert E. Mates. 187, The Metropolitan Museum of Art, New York. 180, Nasjonalgalleriet, Oslo. 43, 44, 45, Nicola Jacobs Gallery. 152, 153, Jeff Nolte. 40, 41, The Pace Gallery. 67, 68, Petersburg Press. 1, 2, 3, 25, 49, 50, 51, 73, 74, 75, Julio Pingarron. 151, George Pivarnik. 181, 182, 183, Eric Pollitzer. 145, 146, Powell Street Gallery. 13, 14, 15, Doris Quarella. 46, 57, 115, 116, 117, 158, 159, 188, 189, Nathan Rabin. 32, Regales Fotografia. 42, Richard Gray Gallery. 56, Curt Royston. 34, 35, 36, Kevin Ryan for André Emmerich Gallery. 118, Francois Thiolat. 133, 134, 135, 163, 164, 165, Tokyo Gallery. 148, 149, 150, Crispin Vásquez. 69, Thomas P. Vinetz for L. A. Louver Gallery. 28, 29, 30, 70, 71, Waddington Galleries. 101, 102, Alan Zindman for Nancy Hoffman Gallery.

Designed by
Frank Garrity Graphic Design

Typography by
Davis and Warde, Inc.

Printed in the United States by
Geyer Printing, Inc.